THE LITTLE BOOK OF
Rodin

Hugues Herpin
Christina Buley-Uribe, Marie-Pierre Delclaux, Hélène Marraud

D0062531

Flammarion

The Story of Rodin 5

Alphabetical Guide

Entries are arranged alphabetically into the following three sections.
(Each section is indicated by a color code.)

The alphabetical entries are cross-referenced
throughout the text with an asterisk (*).

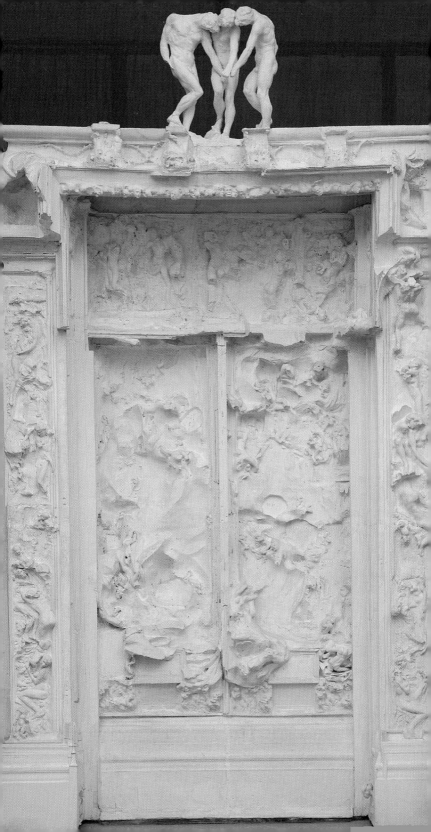

THE STORY OF RODIN

I t is rare for an artist's name to be as closely linked to his oeuvre as Rodin's is to his work. Just as everyone knows that *The Magic Flute* is by Mozart or that *Les Demoiselles d'Avignon* is by Picasso, sculptures such as *The Thinker* or *The Gates of Hell* immediately call up not only the name of their creator, Auguste Rodin, but also his characteristic genius. The comparison can be taken a step further: just as *The Magic Flute* has come to stand for the quest for wisdom through music, so *The Gates of Hell* has come to symbolize all gateways—even if, from the outset, the monumental sculpture was not designed to fulfil its utilitarian function and never opened or closed.

Unlike many other famous artists (for example, Picasso, who was only twenty-six when he painted *Les Demoiselles d'Avignon*), Auguste Rodin spent many long, hard years in apprenticeship before his genius was recognized. It was only in 1877 that news of his work reached the general public after his exhibition of *The Bronze Age* caused a scandal.* This gradual, and eventually controversial, start to his artistic career goes a long way towards explaining certain aspects of Rodin's personality.

Rodin is a multifaceted artist, both in terms of his creations and of his choices concerning materials and genre. There is, for example, still much to be discovered about his drawings and his use of photography. But it is nonetheless true that one aspect remains constant in his work, whatever the style, and whatever the material: the obsessive desire to recreate the body anew by modeling it.

More than any other sculptor, Rodin crafted a thoroughly new vision of his art. After the sculptors of antiquity and the works of Michelangelo, his was the last major contribution to the art of sculpture before the great artistic upheavals of the twentieth century called the traditional principles of representational art into question. His works may be seen as an important link between two centuries of sculpture. The early nineteenth century saw the development of a trend towards Neo-Classicism, which, in its search for an ideal beauty, tended to become rather insipid, and at various stages nineteenth-century sculpture wavered between Romanticism, eclecticism, realism, and symbolism. At the dawn of the twentieth century, young sculptors such as Bourdelle or Maillol, strongly influenced by Rodin's example, marked in their own way a major return to the notion of style. Bridging these two distinct artistic contexts, Rodin's own creations show an aesthetic development which ultimately emancipated itself from tradition and the classical heritage, creating its own entirely new rules.

The Gates of Hell (without the figures), 1900, plaster, h. 17 ft (5.20 m) Musée Rodin, Paris/Meudon.

Rodin in an Artist's Smock, c. 1862. Photograph C. Aubry. Musée Rodin, Paris.

I. RODIN'S LIFE AND WORK
A. From School to Studio

François-Auguste-René Rodin was born on November 14th, 1840, to Jean-Baptiste and Marie Rodin. He attended school, but was a mediocre student. Despite his great difficulty with mathematics, reading, and writing, he enrolled at the imperial school of drawing known as La Petite École at the age of fourteen. There, the teaching was still in the eighteenth-century spirit, in contrast to the more prestigious École des Beaux-Arts, where the training was in accordance with the precepts of the great painter Jacques-Louis David.

At the same time, Rodin was a frequent visitor to the Louvre, where he spent hours sketching the works of the ancients, before attending the evening drawing lessons given by Hippolyte Lucas at the Manufacture des Gobelins. Rodin was also an avid reader, devouring the works of authors such as Alphonse de Lamartine, the Romantic poet, who had a particular impact on the young man. In this way, Rodin absorbed all the cultural references necessary for an artist hoping to forge a name for himself in mid-nineteenth-century France. After three years at La Petite École, Rodin took the entrance examination to the École des Beaux-Arts: he failed the sculpture test three times, passing only drawing on his first try, which was not enough to secure him a place.

Thanks to the training he received as an ornamentalist, Rodin was soon able to find work in Paris, where Baron Haussmann was directing a major rebuilding program. Rodin was able to learn all the tricks of the trade in various studios and workshops throughout Paris, while working on his modeling* and molding skills, as shown by the mask of the *Man with the Broken Nose*, rejected by the Paris Salon—the capital's most prestigious art exhibition—in 1864.

B. Creative Development, Professional Success

After an extended stay of six years in Belgium* (1871–77), Rodin returned to Paris to exhibit *The Bronze Age* in the French capital, where it caused quite a stir. His growing fame—soon confirmed by the acquisition of his *Saint John the Baptist Preaching* by the board of the École des Beaux-Arts—brought him his first public commission, for *The Gates of Hell*, a multitude of forms designed to be included in an architectural* monument. This work was seen through the

The Bronze Age, 1877, plaster, h. 6 ft (1.83 m). Musée Rodin, Paris/Meudon.

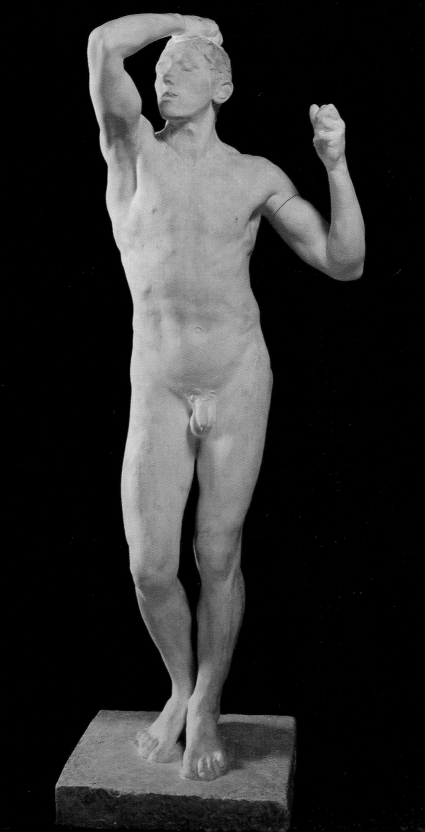

Monument to the Burghers of Calais, 1889, plaster, h. 7 ft 7 ins (2.32 m). Musée Rodin, Paris/Meudon.

prism of one of Rodin's recent literary discoveries, Dante's *Divine Comedy,* and showed the sculptor's sensitivity to the particular atmosphere of Charles Baudelaire's writings.

Rodin's teachers, the great modern sculptors Carpeaux and Barye, were dead, and Rodin himself could no longer bear the work of sculptors such as Paul Dubois, which he admired greatly only a few years before. He had never before followed the example of a

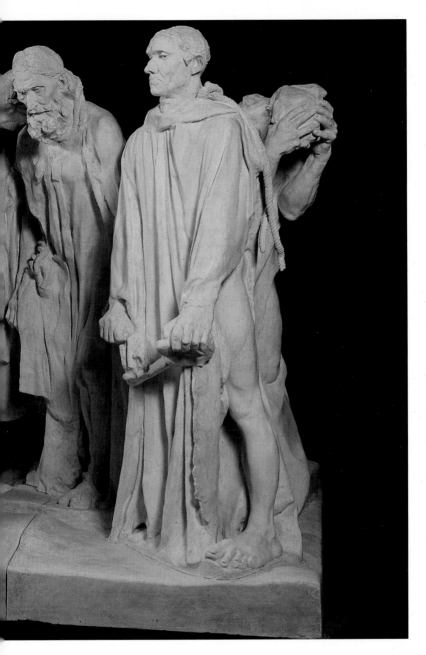

master, but he now chose to model his work on that of Michelangelo, although he distanced himself from those who produced sculptures that were straightforward carbon copies of the master's model, rather than imitations of the spirit of his genius. Rodin considered Michelangelo to be "the last and greatest of the Gothic artists" and in following his example sought to inscribe the tragedy of the human condition into the very substance of his creations.

By now, Rodin was famous for his sculpture: his representation of the great Enlightenment thinker D'Alembert decorated the façade of the Paris city hall and he was much in demand in the most fashionable Paris salons. Apart from his work on the *Gates of Hell* and numerous portraits* dating from the 1880s, he was also entrusted with a number of prestigious commissions: *Monument to the Burghers of Calais* in 1884, *Bastien Lepage* in 1886, monuments to the memory of the artist Claude Lorrain and the writer Victor Hugo in 1889, and finally, in 1891, the work he considered pivotal in the development of his aesthetic, the *Monument to Balzac*.

During the next twenty years Rodin continued to grant himself the occasional outburst of artistic temperament—such as shocking public opinion or failing to meet deadlines—but nevertheless became the most important sculptor of his day. This is shown by the increasing number of his works to be exhibited at the Musée du Luxembourg, which in those days housed an important collection of contemporary art. Rodin also had a considerable, if less immediately obvious, impact on drawing* styles. After his black* drawings of the 1880s, his sole model was the female* form. He used the techniques of collage and paper decoupage,* to either reduce or expand the space around the traced line, which for him was so close to nature,* and the perfect expression of simplicity, capturing only what is essential and stripping away the superfluous. One constant aspect of Rodin's use of form is that whatever the technique used, the texture and volume are more important than the contour and lines.

C. Years of Glory

The Universal Exhibition took place in the year 1900 in Paris. Rodin set up his exhibition* space in Place de l'Alma, slightly beyond the circuit of the official pavilions. Here, 168 sculptures (plasters* for the most part), 128 drawings,* and 71 photographs* were displayed—the sum total of Rodin's artistic production; at the age of sixty, this was perhaps his way of announcing his forthcoming retirement, although this was only his second solo exhibition. In any case, some visitors to the exhibition saw the way in which the show was presented as a precursor to a Musée Rodin—which indeed Rodin himself indicated was the case. To celebrate this great event, the last in a series of exhibitions throughout Europe, he made a number of significant decisions. He chose not to put certain "pleasant" works such as *The Kiss* in the most strategic positions, placing instead his most controversial work, the *Monument to Balzac*, in the center of the space so it would be the first

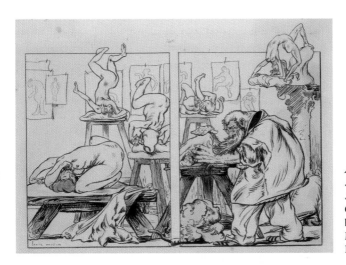

Auguste Rodin Sculpting in his Studio, 1900. Caricature by L. Morin. Musée Rodin, Paris.

thing visitors would see upon entering the exhibition. He also chose to present a version of the *Gates of Hell* stripped of almost all its figurative content; this work was expected to be the show's main focal point, but instead it was hidden away in a corner. In the end, the exhibition sent out precisely the message that Rodin wanted it to. It was an important demonstration of his ideas about presentation.*

After the exhibition, private commissions poured in from all over the world. It truly marked the apogee of Rodin's glory. He was now able to spend his days fervently reworking pieces that, for the most part, he had first created long before—*The Gates of Hell* in particular. The processes of assemblage* or mutilation, with which he had first experimented at the end of the 1880s, he now used on a systematic basis, giving his pieces fresh life. Located near Paris, in Meudon, his Villa des Brillants became the last great studio in the history of sculpture. There, Rodin once more reinvented the art of sculpture and managed his "business" superbly, with the help of a crowd of assistants and a number of brilliant secretaries. Among their number was the poet Rainer Maria Rilke, who crafted words in the same spirit as his employer created poetry in sculpture.

On April 21st, 1906, Rodin attended the inauguration of his monumental *The Thinker* in front of the Pantheon in Paris. He was now able to take advantage of the solidity of his reputation to bring to the fore some of the less prominent aspects of his creative work. Thus, in 1907 he staged an exhibition at the Galérie Bernheim Jeune consisting exclusively of three hundred drawings, taking the step from sculptor to all-round artist. Towards 1910, Rodin began work on *Dance Movements*—sketches that have a genuine sculptural quality.

These studies, designed to seize the essence of movement,* are an extension of the same logic apparent in his drawings from the end of the 1890s: to capture nature* through a simple pencil stroke——with the hand independent of the eye's control, the eye fixed on the model*——and the artist's objective to evolve his art freely in the studio.

II. THE LIVING BODY AS SUBJECT
A. Man at the Center

In stripping away the superfluous, Rodin was engaged in a constant process of studying and representing the human form. But for him, the body was rarely as ideal as the classical tradition demanded. If, as a young man starting out, he attempted to reproduce the graceful style of eighteenth-century sculpture, or was intoxicated by the perfection of antique statues, rediscovering the work of Michelangelo during his trip to Italy* proved a salutary shock, strengthening his refusal to portray human anatomy in a strictly representational way. Far more than a straightforward translation of a real human form into sculpture, Rodin wanted to show reality as he saw it, remaining absolutely devoted to his own perception of nature,* which for him was the origin of everything. He believed that all art was to be found "in nature and the need to express life."

Rodin's indecision and even lack of interest concerning the choice of titles* for his works is well known; in fact, the subject of the work is often little more than the exterior form given to Rodin's one permanent subject, Man. As the modernist sculptor Brancusi later said, Rodin put Man back firmly at the center of representational art. In his studio in Meudon, Rodin worked to abolish the distance created by the subject. This subversion of the more classical, academic tradition is particularly striking in a work such as the *Monument to the Burghers of Calais*, which Rodin felt should involve the onlooker in a process more participatory than purely contemplative. In Rodin's day it was usual for the body to be an object of sculpture, but it was less so to invite the audience to cross the distance—whether physical or imposed by the nature of the subject matter—separating the onlooker from the work of art.

She Who Was the Beautiful Helmet-Maker's Wife, 1887, bronze, h. 19 ins (50 cm). Musée Rodin, Paris.

Rodin had already offended public opinion by over-exposing the body with *The Bronze Age*, which he was accused of having cast from a real life model.* He offended again by "under-exposing" the body in his *Balzac*—the great man was portrayed wearing a dressing gown and his body became no more than a monolithic block with nothing to retain the gaze as it travels over the sculpture. This was Rodin's solution to the question of how best to draw attention to the brilliance

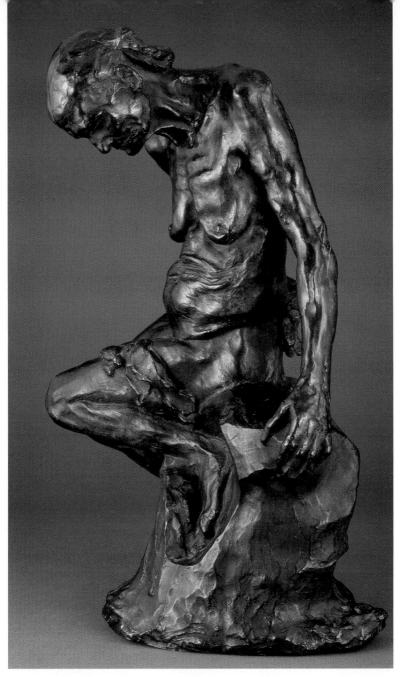

of the spirit shining from the shadowy eyes of the celebrated French author. When Rodin presented this work together with *The Kiss* in 1898, public opinion preferred the soft voluptuousness of the embracing couple,* and one critic spoke of the *Balzac* as an unformed fetus, an unfinished body. Yet in this work, Rodin had taken a decisive step; by re-examining the human form, he had broken free from the narrow representationalism of figurative art.

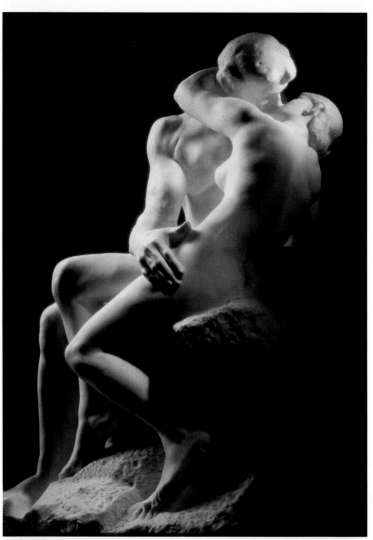

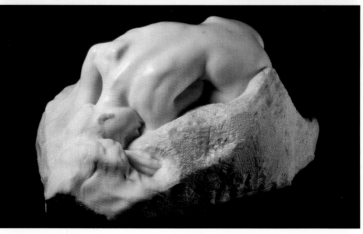

In the same way, the choice of using a fragment* or the technique of decoupage* allowed Rodin to combine his desire to portray the body as a morsel of life with his study of the dynamic relationship between volume and space. All the energy of movement is concentrated in one isolated fragment of the body and the gaze is drawn along lines of force that have been decontextualized by the suppression of all bodily attributes and clues. This can be seen as a way of neutralizing the emotional force of the body, which Rodin considered overly conventional in sculpture, and of underlining the importance of the volume and overall orientation* of the human form.

The Kiss, 1888–89, marble, h. 5 ft 11 ins (1.82 m). Musée Rodin, Paris.

B. The Satyr

The erotic nature of Rodin's work has often been noted, and it is true to say that couples* like those depicted in *The Kiss* or *Eternal Spring* are perfect representations of his gently erotic sensuality. *The Gates of Hell* is entirely based around the paradigm of Eros and Thanatos, depicting the expression of human impulses and their repression. As Camille Mauclair, the Symbolist art critic, rather bluntly put it, "Rodin's entire oeuvre is the story of a soul desperate to escape its body, and choosing to escape by the only route the body allows it: physical love." Even when Rodin depicted the body of woman bearing the marks of a difficult life, as in *She Who Was the Beautiful Helmet-Maker's Wife*, a reference to a poem by the medieval poet François Villon, the sculpture still represented the traces left by physical passion. Rodin also pushed the exploration of eroticism very far in his drawings* and this may be one reason why they were never as widely shown or as recognized as his sculpture. Some of this work was considered erotica* and in his day described as "a series of libidinous pencil drawings."

While Rodin's own statements make his creative process perfectly clear—"In this female nude, I am looking for life and movement; I am trying to translate the suppleness of the human body, and those who see obscenity in my productions are truly backward"—his own image, especially in the latter part of his life, was rather scandalous. The press called him "saucy," an "apostle of vice," a "pornographer," and it is hard not to imagine that his private life played a role in their disapprobation. Rodin had been living with Rose Beuret since he was twenty-four, but also had many mistresses. Isadora Duncan told of how she felt like "a nymph in front of a Centaur" whenever she met Rodin. The artist might have played with this image of himself in certain works; thus, when he was working on the mythological theme

The Danaïde, 1889–90, h. 14 ins (36.7 cm). Musée Rodin, Paris.

15

of the sculptor Pygmalion, who fell in love with a statue of his own creation, Rodin chose to represent a sort of satyr with cloven hooves embracing a female figure by force. The same message is unavoidable in his *Minotaur*—there is the same sense of erotic urgency that is to be found in the works of Picasso, who himself used this figure obsessively.

In fact, while it has become a commonplace to point out the voluptuous sensuality of Rodin's figures, the erotic nature of the interaction between the audience and the sculptures' creator should not be forgotten. Thus, when as part of the sixth Munich Secession exhibition in 1898, Rodin chose to display his *Iris* in such a way that from the perspective of the onlooker, the vanishing point was the woman's pubis, the crudeness of the statue's setting involved the onlooker as one of the poles of erotic interaction. He also had a highly erotic relationship with his female models,* communicating with them in an extremely sensual manner. Contemporary reports eagerly seized on this to perpetuate Rodin's reputation as a satyr.

III. RODIN'S MODERNITY
A. Methods and Media

The Walking Man, 1889, plaster, h. 23 ins (85 cm). Musée Rodin, Paris/Meudon.

In order to understand Rodin's modernity, he should be considered within the context of his entire creative output; not just his sculpture, but also his drawings, and his use of photography* to ensure that his work reached a wide audience. Indeed, Rodin, who all his life moved between different techniques and materials,* could be termed the first "visual artist" in the history of art. For example, his decision in 1908 to revive his *Monument to Balzac*, not as the sculpture itself, but as a photograph of the original by Steichen, is typical.

Rodin also definitively established a place for the unfinished* creation in art. He introduced principles of repetition,* fragmentation* and decoupage,* collage,* and assemblage,* as well as profound insights into the relationship between the sculpture and its surroundings in his work on the plinth* for his sculptures, the use of elements of chance* and of scale,* the status of the object, the concept of installation,* and so on. From the standpoint of art theory, his research into the articulation* of the profile* and the representation of movement* in space with *The Walking Man* brings us directly to the starting point of two of the most avant-garde schools of the period: Cubism and Futurism.

Finally, we should not forget the significance of his artistic process, which aimed to redefine the economic possibilities of sculpture at a time when major public commissions were becoming rarer,

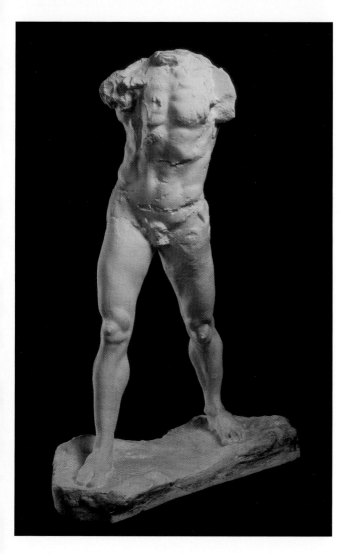

and the nineteenth-century craze for statuary was well past its peak. Rodin was by then an internationally renowned artist, and he sold his works all over the world, proving that once again, the sculptor had no need of institutions and their financial largesse to earn a living. In fact, the rather offhand way Rodin dealt with his last major commission for a public monument, a statue of Whistler—he said in 1910 that it was impossible for him to "set a deadline for the creation of a work of art"—shows that he craved more than the right to be master of his own time. Rodin wanted the right to work without necessarily having the end result of his creative process programmed from the outset. What he wanted was the freedom of *bricolage* (tinkering),* of playing with his own work when the humor took him, creating variations* on themes of his own choosing.

Towards The Light at Midnight, Balzac, 1908. Photograph E. Steichen. Musée Rodin, Paris.

B. Safeguarding a Legacy

After the triumph of his 1900 exhibition,* Rodin was famous throughout the world. His thoughts on art were generally limited to the field he had created for himself, and notably he almost never critiqued on the profound aesthetic changes of the early years of the twentieth century, as if he were holding back from commenting on something whose significance he may have foreseen without understanding all the reasons for it. Whatever the case, it was extremely rare for Rodin to indicate a lack of respect towards other artists, whether predecessors or contemporaries. He was conciliatory in nature, one might say, and even found good things to say about the

work of William Bouguereau, one of the best-known nineteenth-century representatives of the insipid and derivative *pompier* style.

Among his contemporaries, Rodin had a real admiration for the sculptures of Maillol and Bourdelle. He said of Maillol's *Leda* in 1902 "In all modern sculpture, I know of no other piece that is as absolutely beautiful." His admiration may have been in part due to the fact that these two artists were developing in their own way the lessons he had given. Rodin also considered Puvis de Chavannes "the greatest artist of our time." These preferences (evident in his personal collection*) reflect the aspirations of a man in his twilight years thirsting for the peace and tranquillity of antiquity, for whom

the idea of a revolution in art was now impossible, because "progress exists in the world, but not in art," as he said of the unparalleled Greek sculptor Phidias.

Towards the end of his life, it was as if Rodin had decided to distance himself from his contemporaries, not even seeking to understand the latest artistic movements. After Impressionism, called into question as early as 1880 by the Symbolists, then by the Nabis and Expressionism, the Fauvists did away with the few remaining conventional instincts in painting at the Autumn Salon in 1905. Picasso was soon to create Cubist sculpture with his *Head of a Woman* in 1909, the year of Marinetti's Futurist manifesto; at the same time, Derain, with his *Seated Man*, and a year later, Brancusi's *The Kiss*, took the concept of geometric form even further. Zadkine and Archipenko (with his *Dance* of 1912) were working on the notion of volume as a screen for the void and the play of concave and convex forms, while Marcel Duchamp presented his first piece of ready-made art—*Bicycle Wheel*—in 1913. That same year, Boccioni was attempting to "model the atmosphere that surrounds things" with his *Unique Forms of Continuity in Space*.

Rodin Working On Some Small Sculptures, c. 1912. Photograph J.-F. Limet. Musée Rodin, Paris.

Rodin had a rather disdainful opinion of Futurism and Cubism, he called both movements "boastful" in his interviews with the art critic Michel Georges-Michel. However, he could not ignore these movements entirely, as proven by an invitation to the Futurist exhibition of 1913 found among his papers after his death. So why did Rodin maintain such a distance between himself and the new avant-garde movements?

First of all, for the first half of his life he had experienced "all the evils of poverty." The safety of success only came to him later; he had never shown any particular desire for "political" engagement, and once he had found fame, it is understandable that he was reluctant to fight for the recognition of artists neglected or ignored by the establishment. Moreover, Rodin, unlike many artists, never had a studio where his pupils could study systematically, although he did have many students at various stages throughout his life. His teachings were in his works themselves: a certain harmony was therefore a necessity. Perhaps it was a sense of respect for his own image that led him to retain the same artistic choices to the very end, ignoring the aesthetic upheavals of the early twentieth century and seeing only his own vision of modernity—despite the few critics who were beginning to accuse him of blindly following a lesson first given by Michelangelo and Donatello four hundred years earlier.

From 1908, Rodin divided his time between his home in Meudon and the Hôtel Biron. The critics' sniping did not affect him: he was more concerned with posterity and his artistic legacy.* In 1916, he made three successive donations to the French government, thus paving the way for the founding of a museum devoted to his works. Since the 1880s, Rodin had hoarded everything that might come in useful for such a project, from press cuttings to a voluminous correspondence. He donated over 7,000 sculptures, 7,500 drawings,* 8,000 photographs,* and over 7,000 pieces of art from his own private collection.*

Unfortunately, he did not live to see the inauguration of the Musée Rodin in 1919. On November 17th, 1917, Rodin died in Meudon, and was buried there beside his faithful companion, Rose Beuret. They had married less than one year earlier, just before her own death. *The Thinker* stands over their grave in the grounds of the Villa des Brillants. HH

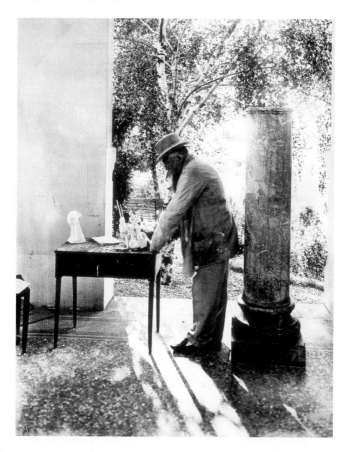

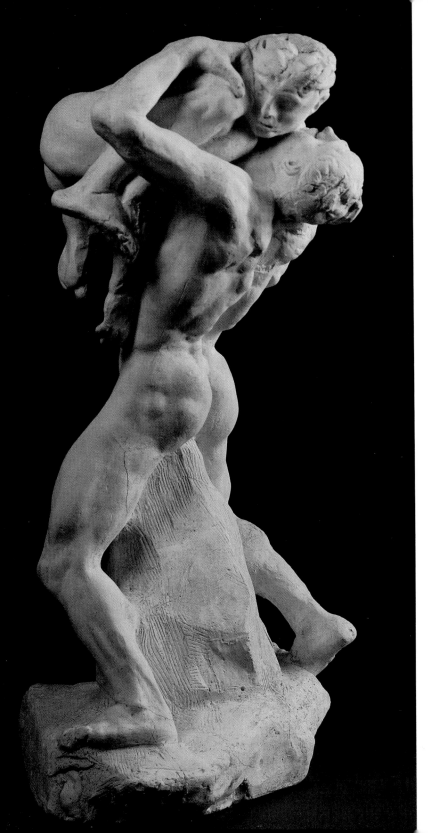

Arch

Rodin, very early in his work, became interested in human figures depicted as tumbling backwards, with their back arched. It seems nothing can slow the momentum of the *Falling Man* (1882) or the *Prodigal Son* (c. 1886), thrown towards the void, their torsos twisting in an effort to resist their fall.

At the retrospective of Rodin's works during the 1900 World's Fair, the artist showed a series of drawings* entitled *Eros*. In each, the same arching figures lean on their forearms, like a bow stretched as far as it will go. In later works, such as his monumental torsos, this same tension is expressed as a body reduced to a simple shape; without head, arms, or legs, the over-sized torso of the *Falling Man*, also known as the *Torso of Louis XIV*, has the powerful vigor of ancient statues such as the *Milet Torso* (in the Louvre) or gilded bronze breastplates from ancient Rome.

For Rodin, the proud chest, rising to meet front-on the light that is weakly distributed over the rest of the torso, summed up all the principles of composition of antiquity. In a famous conversation with Paul Gsell in 1912, Rodin contrasted Greek art with the works of Michelangelo. In the latter's sculptures, he said, "the torso is arched forwards, while in antique art it was arched backwards. This is what produces such accentuated shadows." For Rodin, Michelangelo's torsos celebrated "the epic of the shadow, while the ancients sang the epic of light."

In works such as the sensual *Torso of Adèle* (1882) and *Arched Torso of a Young Woman* (1910), the clearly defined shape of the arch itself becomes an expression of satiated desire. Two sculptors in particular followed Rodin's example: Emile-Antoine Bourdelle, especially in the arched body of his *Hercules*, and Brancusi, in his search for purity through the use of clean lines.
CBU

I Am Beautiful, 1885 (?), plaster, h. 17 ins (69.5 cm). Musée Rodin, Paris/Meudon.

Architecture

Rodin traveled widely in his native France. In Paris, with his companion Rose Beuret, he visited the cathedral of Notre Dame and the hospital

Torso of Adèle, c. 1882–84, plaster, h. 5 ins (13.3 cm). Musée Rodin, Paris/Meudon.

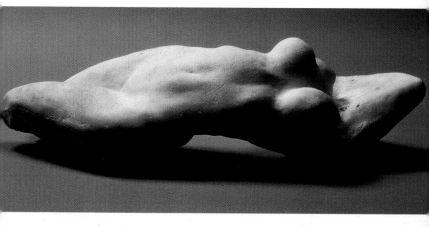

ARCHITECTURE

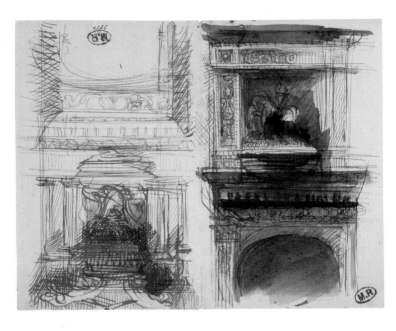

Fireplaces,
brush and
sepia ink wash
on paper,
6 x 8 ins
(16.4 x 21 cm).
Musée Rodin,
Paris.

of Val-de-Grâce. He also visited the Loire Valley on secret trysts with Camille Claudel, and discovered the châteaux of Blois, Azay, and Chambord. Rodin set about sketching various features of the castles with single-minded determination: he left some two thousand drawings* of moldings, cornices, pilasters, windows, consoles, lamps, lanterns, and fireplaces. In his 1914 book *Cathedrals of France,* he wrote that he believed the spirit and essence of moldings represent and signify the architect's whole plan. Anyone who sees and understands the molding comprehends the whole monument. Its gentle curves are those of nature itself, and its life is the life of the whole building.

Rodin's concept of architecture was based on his interest in the finishing details, which is amply reflected in his only two truly monumental projects: *The Gates of Hell* and *The Tower of Labor.* Both of these pieces take their inspiration from a great work of art from the past: the first from the *Gates of Paradise* at the Baptistery in Florence, the second from both the great double helical staircase in the castle in Blois and Trajan's Column. Structurally, the two are placed in similar spaces and each is delineated by flanking figures and a group at the base. Both are also designed to be simple backdrops to a large number of figures, following a certain "sense of arrangement and composition."

When Rodin first showed his *Gates* to the public in 1900, however, he chose to present it bare, stripped of its figures, which created an abstract space that was complete in itself. It was as if he wanted to test whether the *Gates* and their plain, smooth, yet vibrant surface, had a life of their own—whether they represented the essence of architecture. CBU

24

Articulation

All his life, Rodin played with his sculptures, dressing them (*Balzac*), placing objects on their head (*Pallas in the Parthenon*), removing their heads, arms, and legs (see Fragmentation*), and sometimes recomposing them. This gathering of disparate elements in a composition free from all constraints is one of the most important elements of Rodin's desire to play with his sculptures.

His *Martyr* (1885), a reclining Greek slave on the verge of death, has an ecstatic expression said to be borrowed from Bernini's *Saint Theresa*. From the way its limbs are articulated, the figure appears to be suffering. The arms and legs are twisted and stuck into the torso like those of a doll broken then clumsily mended by a child.

The way Rodin manipulated the heads* of his pieces is characteristic of his research into the articulation of the human form.

Stuck on a neck that arches backwards like a branch bending under a weight, the head is sometimes less important than the horizontal lines formed by the shoulders and neck.

Rodin's *Adam*, designed for the *Gates of Hell* in a style that borrows heavily from Michelangelo, is probably the earliest example of this practice, which is to be found in many later works, such as the *Crouching Woman*. In *The Shade*, the distortion is pushed to the extreme. Rodin took these "unformed attempts" even further with the figure in *Meditation*, where the angle of the head and neck is counterbalanced by the exaggeratedly twisted lower torso. In the plaster* model for his *Christ and Mary Magdalene* (c. 1894), the body of Mary Magdalene is bent to the right in a movement* forming a ninety-degree angle, while her left arm, like some oversized transplant, clutches at the cross to prevent her falling. CBU

The Martyr,
1885, plaster,
h. 5 ins (13 cm).
Musée Rodin,
Paris/Meudon.

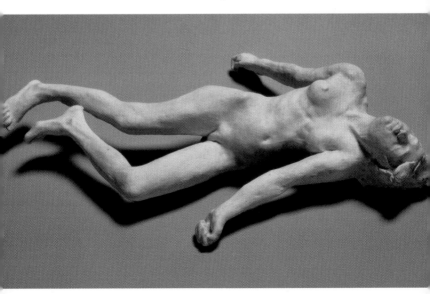

■ ARTISTIC LEGACY
In Rodin's own words:

Bow down before Phidias and Michelangelo. Admire the serene divinity of the first, the untamed angst of the second. Admiration is a generous wine for noble spirits.

Let Nature be your only goddess.

Have absolute faith in Nature. Be certain that she is never ugly and make it your sole ambition to be faithful to her. Work unremittingly.

You sculptors, strengthen your sense of depth. It is difficult for the spirit to familiarize itself with this notion. It can only see representations of surfaces distinctly. It finds it hard to imagine forms in depth. Yet this is your task. When you model your material, never think in terms of "surface," but in terms of "relief."

Your spirit should conceive of every surface as the extremity of a volume which is pushing it from behind. Imagine the shapes are pointing towards you. All life springs forth from a center, then germinates and spreads from the interior towards the exterior. It is the same in a beautiful sculpture, one can always see the signs of a powerful inner impulse. This is the secret of the art of antiquity.

Remember this: there are no lines, only volumes. When you draw, never bother about the outlines, only the relief. It is the relief that determines the outlines.

Push your limits unceasingly. You must accustom yourself to the demands of the work.

Patience! Do not rely on inspiration. It does not exist. The only qualities of the artist are wisdom, attention, sincerity, and willpower. Carry out your task like an honest workman. The most beautiful subjects are those right before you: they are the ones you know best.

Bad artists always look at their work through other people's spectacles.

Imagine what fabulous progress would be accomplished all of a sudden if absolute truth reigned over mankind! Ah! How quickly society would be rid of the errors and the ugliness if it owned up to them, and how quickly our earth would become a paradise!

Rodin Standing In His Studio, Surrounded by His Plasters, 1902. Anonymous photograph. Musée Rodin, Paris.

▨ Assemblage

Rodin delighted in assemblage, a technique in which existing, distinct, autonomous forms were combined to create a new artistic language. He saw this process as taking him right to the very heart of the creative process and began playing with his creations in this way very early on, as works from his youth* show.

The Young Mother and *Passing Love,* for example, both portray the same young woman, with a child either sitting on or lying balanced across her lap. *I am Beautiful* brings together two works—the *Falling Man* holding the *Crouching Woman* in

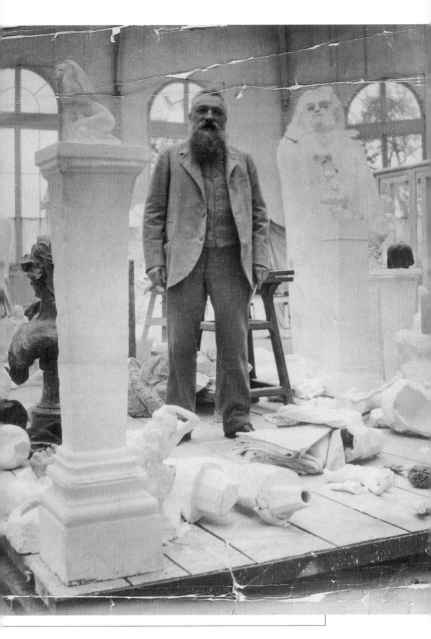

his arms—and in uniting the pair, gives them a fresh lease on life. The delicate pair of figures called *The Dream*, also known as *Kiss of the Angel*, is composed of *Pain* depicted lying on its stomach, surmounted by a *Winged Female Nude*. There are a number of figures that Rodin particularly liked which recur throughout his oeuvre, such as *The Damned Woman*, presented in a reclining position in *Desire*, or leaning to one side in *The Prophetess*.

The fragments * that Rodin invariably used to complete his works are part of the same artistic process. They are

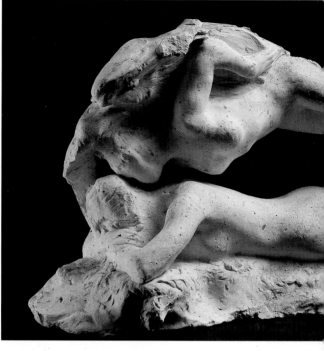

The Dream,
(scale model),
c. 1899,
h. 8 ins (22 cm).
Musée Rodin,
Paris/Meudon.

building blocks in a game where the laws of representational art give way to the higher aesthetic demands of the disposition of forms in space. Several drawings* also present identical, disjointed figures in various orientations.*

Rodin's art of assemblage involved not only figures and forms, but also materials* and even objects, which he displayed in an almost theatrical way. For example, he did not hesitate to place a sprig of holly behind a small figure seated on a rock, or to select vases from his own private antique collection* to contain his nudes,* like the "small floral souls that you have conjured forth," as Rilke wrote to his master in 1908. HM

■ Belgium

The six years that Rodin spent in Belgium, from 1871 to 1877, were, in his own words, "the best and happiest of my life." He had left Paris to follow his master, the sculptor Albert Ernest Carrier-Belleuse, whose eclectic creations were the height of fashion in France's Second Empire (1852–70). Carrier-Belleuse decided to move his studio to Brussels to take advantage of Belgium's neutral status during the Franco-Prussian war of 1870, and Rodin, who had been in his employment since 1864, followed. In Brussels, he was in charge of molding the groups of figures designed, signed, and sold by Carrier-Belleuse to his wealthy, bourgeois clients. Rodin liked to boast that no-one could carry out Carrier-Belleuse's sketches better than he could.

Above all, the lengthy stay in Belgium proved to be the key to Rodin's artistic emancipation. In 1871, he took part in no fewer than four group exhibitions,* in Brussels, Antwerp, and Ghent. In 1873, he signed a contract with the Belgian sculptor Joseph Van Rasbourg,

from their shared studio would be signed Van Rasbourg in Belgium and Rodin in France. It seems to be the case that most of the monumental sculptures signed Van Rasbourg dating from this period were in fact the work of Rodin.

At this time, Rodin also began his international career by showing works in London in 1872, in Vienna in 1873, and in Philadelphia in 1876, as part of an exhibition of Belgian art. The key work dating from his time in Belgium is *The Bronze Age*, which created a scandal* when it was first shown at the offices of the Cercle Artistique et Littéraire [Artistic and Literary Circle] in Brussels in 1877. The piece has since become a powerful symbol of Rodin's talent and vision.

for whom he had already sculpted the caryatids for the Produce Exchange in Brussels. The contract allowed him an equal share of the profits from any public commissions in Belgium, and stated that all works

Brussels always held a special place in the sculptor's heart: not only for its role in his artistic development, but as the place where he had his first solo exhibition, in 1899. CBU

Belgian Landscape, 1871–77, red chalk on paper, 8 x 10 ins (21 x 26.1 cm). Musée Rodin, Paris.

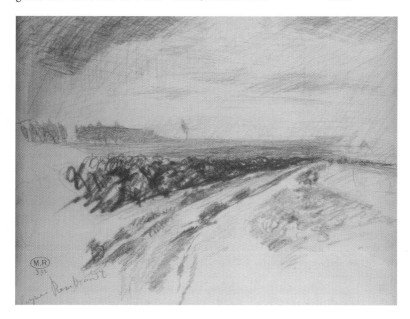

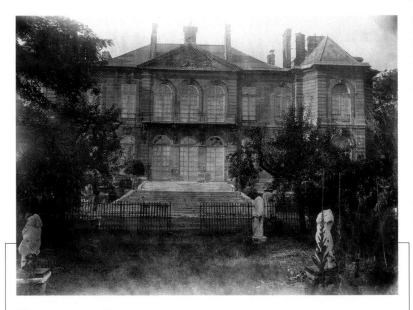

■ HOTEL BIRON
A prestigious site for a prestigious museum

This large and elegant town house is today home to the Musée Rodin, visited by tens of thousands of the artist's admirers every year. It was designed by Jean Aubert in the style known as *rocaille* and constructed between 1728 and 1730. Its first tenant was the Duchesse du Maine, then it was sold in 1753 to the Maréchal de Biron. The building was decorated in the most luxurious style inside and out, from the superb wood paneling and the paintings above the doors by François Lemoyne, the king's official artist, to the magnificent grounds, laid out in the distinguished French style. However, the Hôtel Biron changed hands several times and lost most of its elegance. In 1820 it was acquired cheaply by the Society of the Sacred Heart of Jesus, who stripped it of all its remaining finery and turned it into a boarding school. The building then housed a religious community until 1904.

The Hôtel Biron was abandoned for a few years before it began a new lease on life as rented accommodations. Among its many tenants were Henri Matisse, Jean Cocteau, Isadora Duncan, and Rainer Maria Rilke, who lived alongside humble washerwomen and secretaries. In a letter, Rilke described to Rodin the "abandoned garden, where from time to time you can see rabbits innocently jumping through the trellises as if on some ancient tapestry." Rodin appreciated the wild beauty of the grounds, and moved into the Hôtel's ground floor in October 1908. Rilke wrote,"he wants to bring a lot of things here, and come and look at them from time to time, and contemplate the garden through the grandiose windows here, in this place where no one will think to look for them." From 1911, Rodin was the only tenant of the Hôtel Biron, and was able to surround himself with his sculptures. He placed many of his precious antiques in the shade of the copses in the grounds. He welcomed visitors in this prestigious and elegant setting, far from the Villa des Brillants in Meudon, which was reserved for family* and close friends (and, of course, work*). When Rodin was threatened with eviction, he finally made up his mind to donate his works to the government—an idea he had been toying with for a while—in exchange for the right to remain in the Hôtel Biron. In 1916, he made three successive donations to the state, which was enough to allow the elderly sculptor to fulfil his dream of a Rodin museum and to know that his oeuvre was now safe from the threat of dispersal and would be permanently on display for all to admire. The Musée Rodin opened in the Hôtel Biron in 1919, two years after Rodin's death. MPD

Black

Emile-Antoine Bourdelle was the first person to use the term "black" to describe the drawings* dating from the 1880s in which Rodin modeled a play of light and shadow. Carried away by his reading of Dante's *Inferno*, he returned to earlier explorations in pencil of the male form, and flooded them with ink "at a penny a bottle." The original drawings were simplicity itself: in a child's notebook, he threw down slender silhouettes sketched from memory, the gestures frozen somewhat superficially in artificial poses. By going over these early drawings in ink and gouache, he transformed them into mysterious images like those produced by a medium during a trance—a brand new experiment in artistic terms.

The study of the multitude of bodies disappearing into the shadowy maw of Hell was the real reason behind Rodin's first experiments with decoupage,* profile*, collage,* and the placing of points of light in the sheen of inky blackness. The first efforts involved the materiality of the paper itself, increasing its thickness by sticking layers together. On the surface, the frame of the sheet, trimmed to the outline of the drawing, took on the function of the ink line. In this setting, the opaque gouache threatened to suffocate and crush the forms. The leaden oppression of the damned souls is doubled by the weight of the very paper. The frame, sometimes the

Hôtel Biron, as Seen From the Garden. Anonymous photograph. Musée Rodin, Paris.

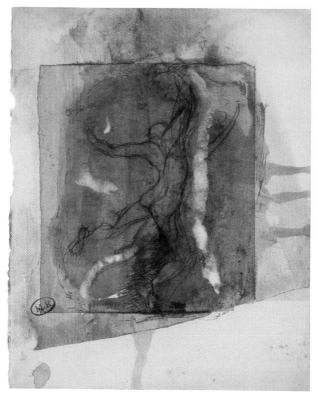

Man Fleeing, c. 1880, sepia wash and gouache on pasted paper, 8 x 6 ins (21.7 x 17.3 cm). Musée Rodin, Paris.

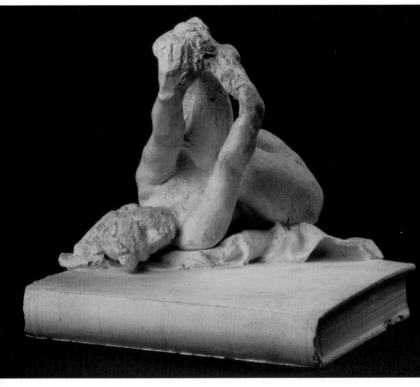

Ecclesiastes,
before 1899,
plaster, h. 10 ins
(26 cm).
Musée Rodin,
Paris/Meudon.

only spatial reference in the image, provides a firm basis upon which the tortured silhouettes seem to be on the verge of imbalance.*

These extremely personal drawings were not often exhibited during Rodin's lifetime.

More than one hundred were included in a limited-edition album printed in 1897 by the publisher Goupil. It is paradoxical that this luxury album should contain Rodin's most intimate works, which capture the essence of his creative activity. The pictures were printed simply as they were drawn, without any effort to dress them up. In these images, experimentation, chance,* and accident become elements of the work of art in their own right. MPD

■ Books

"In my youth, I thought that reading a poem, for example, could help me to understand my art." Rodin tried to forge his own aesthetic vision by reading books* by Musset, Hugo, or Lamartine, whose first _Meditations_ he carried with him everywhere. These books were more than a window open to the world; they prompted him to develop his own thoughts, echoing as they did his interests and preoccupations. Thus Dante and Baudelaire accompanied him to the limits of his own exploration of the expression of human passions. He drew on the wealth of their structure and spirit: "The poet's expression is always primitive and sculptural, it seems to me."

This source gave rise to works of the greatest importance. Rodin later discovered ancient authors such as Ovid, Homer, and Virgil, and would describe their literature in terms of sculpture: "What force, and what weight, in the epithets that Aeschylus uses to project his thought, what powerful short cuts in the images he uses to affirm and set their contours." Every text generated a process of reflection and projected itself in his work.

As Rodin grew older, he took even more pleasure in reading. At different periods, he appreciated Goethe, Pascal, the historian Jules Michelet, Plato, and Sophocles. A particular favorite was Rousseau's *Confessions*, which he read and re-read many times. Sometimes, when he was in his garden or studio,* Rose would read aloud to him, but his reading habits were frequently chaotic and occasionally laborious, often interrupted by the imperious need to jot down a thought or produce a quick sketch of

something that caught his eye. Many contemporary writers— Stéphane Mallarmé, the Goncourt brothers, Anatole France—as well as hundreds of others, sent him copies of their works in homage to his genius. He is known to have read some, but never touched others. In the end, his *Ecclesiastes* bears witness to his philosophy on life: "Nature is the most beautiful of books; you just have to know how to read it." MPD

▪ Bricolage
(The art of tinkering)

In Rodin's oeuvre, the term *bricolage* represents the part of the creative process that lies beyond the artistic consciousness proper. The term refers to the spontaneous way the artist transforms whatever comes to hand, deploying materials* in new and unexpected ways. *Bricolage* can also be a short cut, the result of the artist's need to pin down, rapidly and precisely, a new idea, which he will later take

Lovers' Hands (scale model), before 1904, plaster and brick, h. 5 ins (13 cm). Musée Rodin, Paris.

the time* to develop more fully. Examples in Rodin's work include the bricks that prop up the study of *Lovers' Hands,* the little head of the *Slavic Woman,* or the *Seated Torso* placed on two plaster points attached to a small plank of wood. Several of Rodin's plasters* have plinths* that might seem out of place, presented to the viewer as unadorned as they were when they were created in the sculptor's studio.

Nothing was wasted: everything was put to good use. In the model for *Sleep,* which is an assemblage* of various materials, Rodin even used crumpled newspaper to fill in gaps or to simulate folds of cloth. Small pieces of fabric were also used in some compositions, such as in the *Siren,* where a piece of cloth is delicately coiled on the back. Rodin's love of nature* is reflected in the use of vegetation—branches and leaves of holly—in certain sculptures. Rodin even came up with his own special glue which permitted him to adhere his drawings wherever his intuition led him. Even in his engravings,* he used a tool he had fashioned from a needle. Rodin's creative passion led him to new heights of ingenuity and inventiveness in the pursuit of his work* as a sculptor. HM

Eve,
c. 1881,
bronze,
h. 5 ft 8 ins
(1.74 m).
Musée Rodin,
Paris.

Bronze

Rodin declared in 1911 that "bronze is always the most advantageous material for my sculpture, because it holds the form of the initial model best. Since marble is but a translation, I can't be as sure the form will be so similar." What Rodin tried to reproduce in bronze was not just the responsiveness and plastic qualities of clay, but also the traces* of the intermediate casting in plaster,* leaving the "seams" clearly visible. In a similar vein, he often chose to leave pieces of the frame that had supported earlier versions in the bronze, even if they no longer had any function other than to point out that the finished product was the result of a working process. Although Rodin did not always follow the same procedure for the production of his works, he did employ some thirty casters, whose job it was to reproduce in bronze the exact surface—imperfections and all—of the model Rodin gave them, most often a plaster piece.

Some works were reproduced in large quantities, such as *The Kiss* or *Eternal Spring.* In Belgium,* Rodin even sold the rights to *Suzon* and *Dosia* to the Compagnie Générale des Bronzes [General Bronze Company]. Other subjects were only cast in bronze once, such as *The Three Virtues* and *The Creation.* In such cases, the bronze casting was probably not carried out for commercial purposes, but rather as a means of fixing definitively a fleeting thought represented by a sculpted form. Paradoxically, while all monumental sculpture of the period was systematically cast in bronze, Rodin died without ever having seen his two greatest works, *The Gates of Hell* and *Balzac,* in their bronze versions. In accordance with the terms of the 1916 donations, the Musée Rodin, as owner of the rights to the artist's work and in the name of the French government, instituted a policy of continuing to cast original bronzes. Today, by law, the number of such casts is limited to twelve per subject. HH

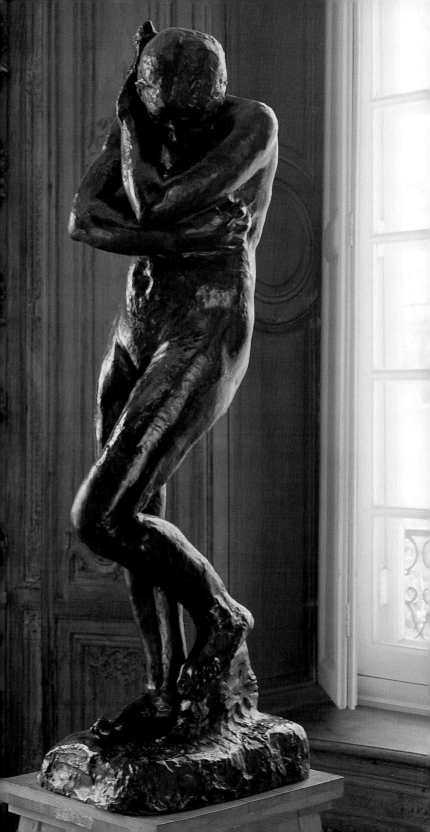

Study for the Nude Balzac and a Gothic Cathedral, 1891–98, pencil on cream paper, 7 x 4 ins (18 x 11.5 cm). Musée Rodin, Paris.

Facing page: *The Cathedral*, 1908, stone, h. 15 ins (64 cm). Musée Rodin, Paris.

R odin was a fervent opponent to the restoration of French cathedrals undertaken by the celebrated architect Viollet-le-Duc, considering the program an act of vandalism. For him, "all France is in our cathedrals; these dolorous virgins, all afflicted, yet all sublime." His love of these "living old stones," as well as his strong patriotic feeling, prompted him during the First World War to participate in the publication of letters of protest against the destruction and devastation of French churches by the German bombardments.

Rodin's fresh and original vision of French cathedrals was illustrated by the publication of his *Cathedrals of France* in 1914. He had learned to appreciate these magnificent Gothic constructions during his youth.* When he set out to learn about Michelangelo, the first superb cathedral he discovered was in Rheims. Rodin loved the impact of the building as a whole as much as he did its individual decorative details. In his book, he wrote: "And so flowers gave rise to the cathedral...." In his private collection* he treasured molds of leaf designs—used to decorate the tops of columns—just as much as he did fragments of antique statues. Even towards the end of his life he enjoyed going on excursions to cathedral cities within reach of Paris, such as Chartres, Rheims, Beauvais, Senlis, Laon, and Amiens. Sometimes he would disappear for days on end, and on his return announce, "I have been to see some cathedrals."

On his travels, he would fill entire notebooks, or even cover the backs of postcards and hotel bills, with sketches not just of cathedrals, but also of small country churches. He kept what he

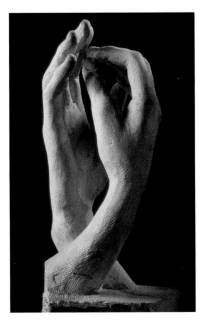

could of these sketches executed from life, even to the most modest of drawings.* He would use them later as a source of fresh ideas. For example, on one leaf from a sketchbook, he wrote the words "Gothic cathedral" next to a sketch of the church of Saint Christopher in Houdan and a powerful sketch for his *Balzac*, associating his planned homage to the great author and the majesty of the cathedral, the two linked by the notion of their sheer grandeur.

For Rodin, the cathedral was a unified whole, and he hoped to be inspired by the same sense of unity and splendor in creating his own sculptures. When he increased the scale of a sculpture of hands* and created *The Cathedral*, the piece took on the stature of a monument. In his words, "the cathedral is the staple that holds everything together; it is the knot, the pact that binds civilization." CBU

Butterfly,
pencil and water-
color on paper,
10 x 12 ins
(25.2 x 32.7 cm).
Musée Rodin,
Paris.

■ Chance

While chance obviously plays a part in all creative and artistic processes, thanks to his careful observation of nature* and his constant readiness to be amazed at natural phenomena, Rodin was able to make particular use of haphazard effects and accidental traces* or meetings that chanced across his path. He was thrilled when his constantly observant eyes caught the pattern on the leaf of an apple tree in the garden, or the way the light picked up the marks left on a lump of clay by the wire used to cut it, or the silvery trail left by a snail, which he observed at the home of his friend M. Vivier: "the path was traced by a superb molding; which makes me think that what we call chance is a law like the one by which our internal organs live, without consulting us."

On occasion, a happy accident had a direct influence on an individual work: the head* of the *Man with the Broken Nose,* for example, was turned into a mask thanks to a chance frost; the concealed early pregnancy of his model* Abbruzzesi, subtly transformed when she posed for his *Eve,* mother of the human race. Legend has it that the block of marble* provided by the French government for *The Kiss* was not quite large enough,

"Something happened to Michelangelo which often happens to us: he ran out of stone. You measure its dimensions, you start working, then you increase the scale and you arrive at the bottom too fast, and there is no more stone. The bottom is unfinished, and without realising, you find it more beautiful than the part that is finished. It doesn't matter that there is no more stone: it's like a great man who does not finish his career. It doesn't mean his life is not a whole."

Rodin

Robert Vaucher, "Un ami de Rome: Auguste Rodin," *La Revue d'Italie* (1914).

obliging the sculptor's assistant, Jean Turcan, to portray the man's big toe as curled under, thus complementing the tension of the body as a whole.

As Rodin said, taking advantage of chance is an art in itself, but it was one at which he excelled. For instance, he recreated years later the beautiful crackle effect found on a study of a torso for *Saint John the Baptist*, forgotten and left to dry too long, for *The Walking Man*. Taking advantage of chance is also knowing how to use a drip of color, to choose the right material* for each work, and to turn every chance discovery into the basis for a new creative adventure. Things cannot go wrong when the artist is relying on the effects of chance. MPD

■ Child

Rodin drew and sculpted children from the very beginning of his artistic career in Belgium,* where he often placed *putti* and cherubs in the (perhaps rather insipid) works he designed for the commercial market. *The Toilet of Venus, Venus and Cupid, The Secret of Love*, and *Fortune with a Child* show pretty young women of the sort to be seen in eighteenth-century Sèvres porcelain, and round, smiling babies with the "so seductive charm" that Rodin saw in the works of the French sculptor Clodion.

These chubby children, their abundant hair falling in pretty locks, have all the attributes typically associated with cherubs, including wings and a quiver of

Page of Sketches, c. 1875–76, pencil, pen, sepia ink wash, and red chalk on paper, 10 x 10 ins (26.3 x 26.4 cm). Musée Rodin, Paris.

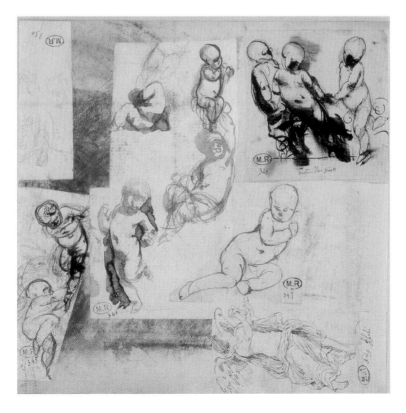

arrows. Rodin's *Idyll of Ixelles* (1885), like his *Embracing Children* (c. 1885), were designed in the spirit of Cayot's *Cupid and Psyche* (1706) and placed the sculptor at this time firmly in the continuity of the classical tradition. The dry-point engraving *Love Ruling the World* (1889) carries an echo of the children hanging like bunches of grapes in Clodion's work *Monument to the Montgolfier Brothers' Hot Air Balloon* (1784–85).

In his later, more modern period, Rodin did not entirely abandon the motif of the *putto*. He made innumerable pencil, red chalk, and ink drawings* of babies, and he also depicted groups of children in various places in *The Gates of Hell*. There is the same profusion on the vase *Illusions* created by Rodin for the Sèvres porcelain factory, the Manufacture de Sèvres, where he came up with many designs for vases and dishes. In these designs, he turned to light-hearted subjects, some with a certain pagan sensuality. Processions of cupids, satyrs, centaurs, sirens, nereids, and bacchantes dance round the pieces, prompting the art critic Roger Marx to say that Rodin had picked up the tradition of "Leonardo da Vinci, Corregio, Prud'hon, all the masters of charm and grace." CBU

▌ Cloth

Cloth is used in sculpture studios* to cover the clay and keep it moist and malleable and, in doing so, the weave of the cloth becomes imprinted in the clay. However, cloth played an unusually large role in the composition and display of Rodin's sculptures: it was a creative element in itself, bridging the transition between two forms and producing effects of drapery. In the latter case, it existed in contrast with the nude,* since "it is what the eye does not see, and is the key element." Rodin played with the potential uses of cloth without trying to give it a definite form or particular movement, since "as the shape of the folds varies, the sitter around whom I throw the drape does not give the same effect twice." He clothed the figures in the *Monument to the Burghers of Calais* in real shirts to evoke the clothing of the historical characters described by the medieval historian Froissart. The research he carried out for his *Balzac* led him to cover his subjects—whether shown with a large belly or an athletic physique,—with cloth dipped in liquid plaster.* In this way, the folds of the cloth did not conceal the body, but rather highlighted its build. The most spectacular example of this is the use of a dressing gown for his *Balzac*, which he obtained from the late author's tailor. It contains nothing but empty space, yet is a precise image of the outlines and volume of the body it once enveloped.

Rodin often used cloth as a transitional material. In the *Meditation* or the *Monument to Victor Hugo*, it was dipped in liquid plaster, then delicately placed to enfold part of the left leg, giving an incredibly fluid image of movement. In the large plaster of *Ugolino and his Children*, the cloth is draped over the figures, linking one to another. In *Absolution*, the torso of Ugolino is draped in a large cloth, and the movement continues upwards with the vertical figure of *The Earth*. The artistic benefit of cloth is that it hides

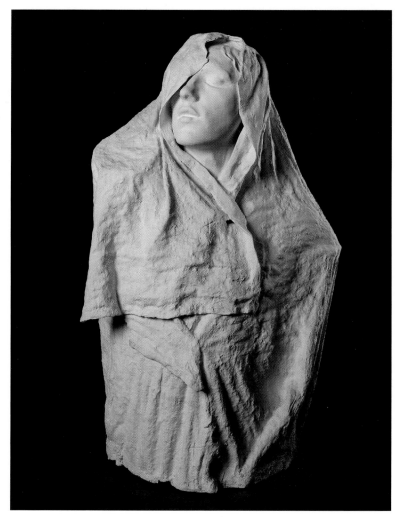

and reveals at the same time: the draping on the torso of *The Bronze Age* gave the sculpture a feminine grace, and the wound on the forehead is figured by a tear in the cloth. HM

Collage

In Rodin's works, the technique of collage developed in parallel with his drawing.* Because as a technique it implied the definitive destruction of drawings or sketches he was unhappy with, he first used it to gather the drawings dating from his youth* in a presentation album or notebook. These collections indicate that at that time, Rodin did not pay any attention to layout, but rather contented himself with cutting out and sticking one small drawing next to another. Since the paper he had used for these early drawings—torn from school exercise books—did not age well, it needed to be strengthened when he decided to go over some of the sketches in ink or gouache in the 1880s. By sticking the paper to a sheet of a larger format, he was able to add touches to his earlier works. The technique of collage thus started out as a simple means of reinforcing the strength of the

The Bronze Age, Draped Torso, c. 1895–96, plaster, h. 20 ins (78 cm). Musée Rodin, Paris.

Sibylle Asleep Over Her Book, c. 1880, ink wash and gouache on pasted paper, 11 x 7 ins (29.1 x 19.8 cm). Musée Rodin, Paris.

paper. However, during Rodin's black* drawing period it gradually developed into an artistic tool in its own right. It played with the notion of the limits of the page—a limit that collage could transgress—while at the same time, the artist was working on the concept of proportion in the drawings themselves. The drawing was now filled with heterogeneous spaces defined by the manner in which the parallel edges of the collage elements fitted together. Rodin worked with the idea of the void, the space between the line and the edge of the sheet of paper, while at the same time exploring the notion of the frame itself, sometimes using printed paper taken from the catalogue of a fabric company or from an accounts book. Thus he carried out his experiments with *bricolage,* exploring the potentialities of various materials.*

Little by little, once Rodin had learned to enlarge his formats by playing with orthonormal cutouts and the technique of *mise en abîme,* his use of collage returned to its original function as a form of assemblage.* In particular, he developed his exploration of the point of articulation*, the contact between two cut-out figures depicting a female couple.* In parallel with his sculpture, Rodin developed the potentialities of a technique which others were only just beginning to explore. MPD

■ COLLECTING: A SINGLE-MINDED PASSION

After his purchase of the Villa des Brillants in Meudon in 1895, Rodin began collecting great quantities of different kinds of art. He collected contemporary drawings and paintings, Japanese prints, Persian albums, antique bronze and marble statuary, medieval sculptures, Coptic cloth, Egyptian sarcophagi, pianos, vases, and so on. It was an eclectic assortment, reflecting his interest in pieces he found exemplary of some aspect of artistic perfection that he wished to study, whether it was the essence of volume in Egyptian art, the expression of movement in the Greek tradition, the absolute simplicity and purity of the line in Japanese art, or the formulation of the emotions in medieval art (the great *Christ* in the bedroom in Meudon is a case in point). Rodin owned three works by Van Gogh, including the famous *Père Tanguy*, as well as a Renoir, a Monet, many paintings by his friend Eugène Carrière, a Zuloaga, a Thaulow, and works by Falguière, Ribot, and many other minor artists. He had acquired some of these works by exchanging them for one of his bronzes* or drawings.*

But the focal point of his collection were the works from antiquity. For the most part, these were vases and fragments of sculptures purchased from antiques dealers in Paris or in lots at public auction. The loveliest fragments were put on show on special plinths* or in display cases. In 1905, Rodin wrote to his friend Hélène de Nostitz, "Now I have a collection of mutilated gods, in pieces, some of them masterpieces. I spend time with them, they teach me, I love this two- or three-thousand-year-old language, closer to nature than any other. I believe I understand them, I visit them continuously, I find their grandeur gentle." In 1906, he had a special building put up to house them in the grounds of the Villa des Brillants, which later became his own private antiquities museum. CBU

Rodin in the Midst of his Antiques Collection, 1910. Photograph A. Harlingue. Musée Rodin, Paris.

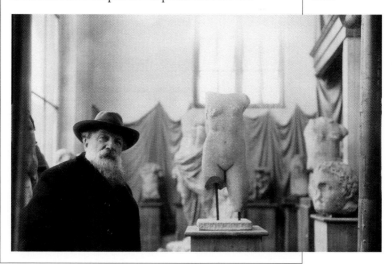

COUPLES

*Two Women
Embracing,*
c. 1890,
terracotta,
h. 9 ins (23 cm).
Musée Rodin,
Paris/Meudon.

■ Couples

Rainer Maria Rilke wrote: "A hand placed on the shoulder or the thigh of another body no longer quite belongs to the person whose hand it is: it and the object it touches or grasps together form something else, something new, which has no name and which belongs to no one." Rodin was passionate about depicting groups of figures, the way their bodies connect or are separated, when a spark of life—or sometimes the heavy hand of death*—unites them. The first couples he depicted were mothers with their children *(Young Mother,*

Young Mother in a Grotto, Passing Love), whose gentleness is opposed to the images of fatherhood,* which often have a violent and ambiguous tone.

The most emblematic depiction of a couple is, of course, *The Kiss* (1882–86), which was originally designed to be part of the *Gates of Hell.* It avoids the tragedy of the *Gates,* offering instead a harmonious and sensual vision of love, which is also to be found in *Eternal Spring* (1884). But for Rodin, women* were distant, even cruel, in awakening desires that they refuse to satisfy. This is the image presented in *The Eternal*

44

"*Flowers, like women, only exist for hands in love with suppleness. They have no need to try to attract admiration: all they need is within themselves.*"

Rodin, *Notes and Scribbles* [*Notes et brouillons*] VI.

Idol (1889). In *I Am Beautiful*, some lines of poetry by Baudelaire inscribed on the sculpture indicate the woman's true nature: "And my breast, upon which each is bruised in turn, inspires in a poet love silent and eternal like that of the material." The embrace becomes more violent and fiery, and in *Fugit Amor*, the man attempts in vain to restrain the woman who inexorably tries to flee. On occasion, the image is inverted, and it is the woman who clings to the man *(Sin, Influence)*. In addition to these couples whose love seems to be cursed, designed for *The Gates of Hell*, Rodin also depicted lesbian couples, such as the *Damned Women*, in provocative poses. He also drew on mythology to illustrate subjects such as *Daphnis and Lycenion*, *Cupid and Psyche*, and *Zephyr and Psyche*, which give a more serene image of the joys of love. HM

■ DANCE

Rodin was deeply interested in dance, especially during the last twenty years of his life: it was a crystallization of his interest in movement* and inner expression. In the early years of the twentieth century, the European traditions of classical and folk dancing were given fresh vigor by the introduction of new trends from the United States. Through the performances of such stars as Loïe Fuller, Isadora Duncan, and Ruth St. Denis, dance came to be seen as an art that summed up all others. Mario Meunier, one of Rodin's many secretaries, wrote that for the sculptor, "It is the whole of painting, sculpture, and music that spring into life." But the fluttering veils of Loïe Fuller, which inspired so many of his contemporaries, were too universal for Rodin's taste, and he never depicted her in sculpture.

In Isadora Duncan, on the other hand, dance found the perfect expression of human nature. Her dancing spoke to Rodin's own thoughts on the expression of human emotion: "She makes dance aware of the importance of the line, and she is as simple as Antiquity, which is the synonym of Beauty." Her style was inspired by the ancient Greek dances, instinctive and close to nature.* Unfortunately, she never dared to dance for Rodin, saying she could not overlook his imposing oeuvre. Nijinsky, however, gave Rodin the opportunity for a magnificent sculpture. The statue appears imbalanced,* with the articulation* of the body— part-facing, part-profile—that had so fascinated Rodin when he saw the dancer performing with the Russian Ballet in 1912. It seems that the dancer is beyond the laws of gravity and that nothing can bind him to the earth. The Oriental dances of Ruth St. Denis, as well as Alda Moreno's performances at the Opéra Comique in Paris, were also the subject of sculptures. Rodin was not just attracted by the exoticism* of the Javanese women dancers at the World's Fair of 1889, or the Cambodian women he so enjoyed sketching in 1906, or even Dourga the Hindu dancer. He was also interested by the women dancing a traditional *bourrée* that he saw as early as 1897, by flamenco, and by the cancan performed at the Moulin Rouge. Rodin wrote that suppleness was "the real law today, it is life itself; it is the possibility of several lives, several movements of life." He produced a rather atypical series

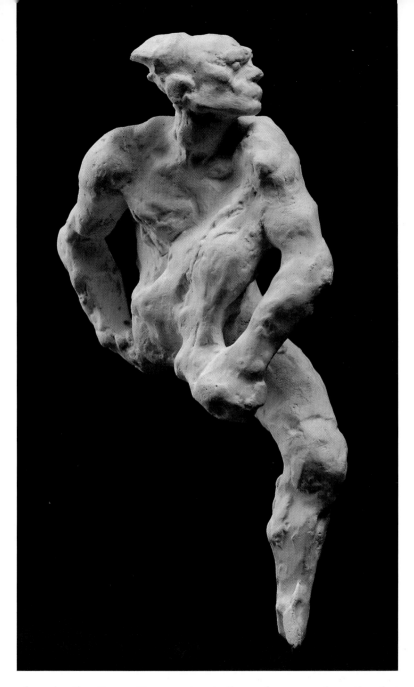

of works, the *Dance Movements*, extremely free in style, far removed from the "on the spot" sculptures Degas had executed twenty years earlier. The series represents the final result of Rodin's researches into the flexibility of the body and the way this contributes to the performance of emotion that Rodin admired so much in Nijinsky. These works, completed at the same time as Matisse's great paintings on the same theme, are the only sculptures to result from his study of dance. Like his *Nijinsky*, he never exhibited them. MPD

Saint John the Baptist and Three Hands, c. 1910, plaster, h. 6 ins (17.4 cm). Musée Rodin, Paris/Meudon.

■ Death

"Facing her, my impression is different every time, but it is always a feeling of unease. I cannot say that she resembles Death; on the contrary, she is so alive that she is supernatural." This is how Judith Cladel expressed her feelings about a glass head* depicting the Japanese dancer Hanako. The piece, translucent white, does indeed have something of the death mask about it. Rodin also produced an intentionally realist polychrome version of the same work, reminiscent of religious statuary from centuries past. He asked Albert Harlingue to photograph the piece placed on a cushion on a bed: the resulting image seemed to be an illustration of a decapitated head.

It is clear that Rodin meant to make the viewers feel ill-at-ease, and the predominant feeling is one of eeriness. The search for incongruous and unsettling effects is also apparent in *Saint John the Baptist and Three Hands,* for if there are three hands, there must be another—unseen—body. This last work is an assemblage* of amputated plaster limbs, brought together in about 1910 in a wood medallion which gives the work as a whole the look of a reliquary. Another macabre collection is the *Assemblage of Heads and Hands from the Reduction of the Burghers of Calais, Surmounted by a Winged Figure* (post-1900). This work is a composition of heads and hands parted cleanly from the body as if by a guillotine. This brutal presentation can be seen as an echo down the centuries of the sacrifices made by the burghers of Calais to safeguard their town. Other of Rodin's works engage the theme of death in a less morbid fashion, such as the *Death*, exhibited in 1900 with the title* *Man, by his Death, Returns to Nature*, which Rodin later renamed *Transformation*. These two

works have a Symbolist tonality: both figures are depicted as becoming overgrown with flowers and leaves.

Rodin only carried out a very few commissions for funeral monuments; among the ones he did accept were a *Hand from the Tomb* (1914) and the *Mother and her Dying Daughter* (1908) for a child's tomb. This piece is a touching composition in the style of Eugène Carrière. CBU

▮ Decoupage

In artistic terms, decoupage is powerful because of its finality. It often appears as a kind of summit in Rodin's drawings.* The artist saw it as a transitional act, echoing his research as a sculptor. In his black* drawings, like the mass from which the sculptor draws out a figure, the scissors cut the paper as if it were a three-dimensional block, following as closely as possible the outline of the drawing, giving the void that separates it from the edge of the page the solidity of matter to be chipped

away. Rodin chose to use the technique of collage,* sticking paper to sheets of a larger format, to leave behind this direct reference to the techniques of sculpture and return to drawing. He enjoyed the chance this technique gave him to go beyond a straightforward reduction of scale to work directly on the form of the piece, as if attempting to radicalize the outline of watercolor or gouache that he used so often. Following the outline with a pair of scissors allowed him to take the work to the limit, to delineate the profile* of each shape, and to free the figure once and for all from its paper prison. It was a deliberate decision to condemn the rest of the blank sheet to oblivion and at the same time a second chance to improve the perfection of the outline.

Decoupage gave the artist freedom to amend his work by physically removing imperfections. Rodin found that his pieces became more representational when he applied a radical version of a method he was particularly fond of: hiding one aspect to make another stand out more clearly. The method is not for the irresolute—once a drawing has been cut there is no going back. When the scissors cut within the line traced by the pencil, amputating a limb or separating the outlines of two women that originally formed a couple;* decoupage evokes the fragmentation* that is such a familiar aspect of Rodin's sculptural oeuvre. Once the superfluous has been disposed of, the emancipated figure can take flight* freely and become a discrete graphic element in an assemblage* along with other watercolor figures, to form a new syntax of artistic forms. MPD

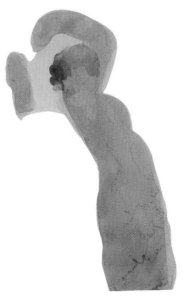

Female Nude, Seen From the Midthighs Up, Arms Raised, pencil and watercolor decoupage, 12 x 5 ins (32.2 x 12.9 cm). Musée Rodin, Paris.

■ DRAWING

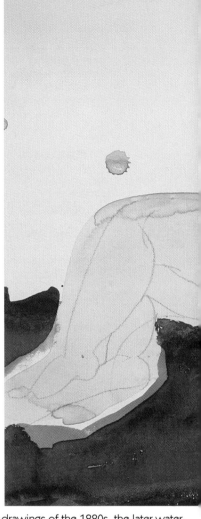

"I have been drawing all my life, I started my life drawing." To the very end of Rodin's life, drawing was a way for the sculptor to carry out his research, and his only creative outlet when he no longer had the strength to work with clay. From his youth,* he had the sharp eye of the draftsman, trained to work from memory, and for whom each and every detail adds to the impression of the whole. Studies of the human form and of human and animal muscle structure, street scenes and landscapes, architecture*, and ornamentation* were all put to good use to train the eye and the hand in the single-minded pursuit of understanding and assimilating the essence of the object. His compulsive need to take note of everything was sometimes so pressing that Rodin did not even have time to find the appropriate paper for the drawing—sketching on notepads, calling cards, the backs of letters or printed sheets and even envelopes. This habit bears witness to Rodin's desire to spontaneously grasp the visible world and make it his own. These drawings from nature became more refined and purer in style, focusing in the end on architecture and the (almost always female) nude* in the studio. He covered thousands of sheets of paper with these two themes, always with the same passion—the real motive behind his research on the "fleeting truth" of movement.*

A glance through Rodin's graphic works highlights the fact that beyond the progressive dilution of the blocks of shading and the lines, touching up the drawings was a vital part of Rodin's creative process. The black drawings of the 1880s, the later watercolors, and the gray* pencil of his last years are in fact reinterpretations of earlier drawings, without a single thought to finishing, exhibiting, or publishing them. Rodin's choice was determined by a sloping line, a movement, a line, a shadow, or a light, that begged to be highlighted, accentuated, or, on the contrary, covered up. These reinterpretations became less and less obvious, as they were sometimes erased or hidden under writing; they came to be the real start of the creative process.

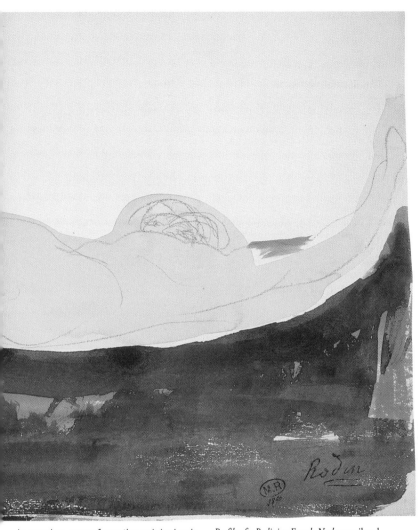

In moving away from the original subject and working on the notion of pure form, Rodin produced a perfect concordance between his drawing and his sculpture. The various techniques and aspects of his work—assemblage* and collage,* decoupage* and fragmentation*, outline and profile*, mold and copy, annotation and plinth*—echo and complement each other, shedding light on the oeuvre as a whole. In 1910, Rodin himself said, "It is very simple, my drawings are the key to my work." Two years later, he went further, claiming that drawing was "my whole life." MPD

Profile of a Reclining Female Nude, pencil and watercolor on paper, 9 x 12 ins (24.6 x 32 cm). Musée Rodin, Paris.

■ ENGRAVING
The secret virtuoso

Although Rodin produced a tiny number of engravings in comparison with his drawings*—some ten prints as compared to more than seven thousand drawings and sketches—the works he did produce in this genre were done at a vital point in his career: the years of intense work* on *The Gates of Hell*.

Rodin learned the technique of dry-point engraving during his first visit to England in 1881. He studied with his old friend from La Petite École, Alphonse Legros, who had progressed from a career as drawing master to teaching engraving at a school in South Kensington in London. It was Legros who taught Rodin to transform the rather naive style of his first attempts into spectacular displays of virtuosity. In 1884, Rodin produced *La Ronde*, based on the cut-away images of his black* drawings, but his most significant engravings were in fact probably those based on his sculpted portraits* of Victor Hugo (1885), Antonin Proust (1888), and, above all, Henri Becque (1887). This last work, a triple portrait on the same plate, is his most impressive engraving, and at the same time, the most clearly modern. It features the three-fold repetition* of the subject's head,*the black lines accentuated like slashes across the paper.

Rodin picked up on the effect of hatching typical of engraving in many pen and ink drawings dating from the 1880s. His illustrations* for Baudelaire's collection of poems, *The Flowers of Evil,* drew heavily on his work as an engraver. The same style can be found, with a sharper dynamic, in the drawings of his sculptures *The Bronze Age* and *Saint John the Baptist*. These drawings were produced for publication in art revues to increase awareness of his sculpted work; they are not the most personal of his drawings. In 1908, Rodin became president of the Société Internationale de la Gravure Originale en Noir [International Association of Original Black-Ink Engraving]. CBU

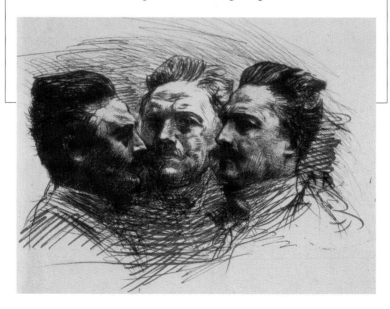

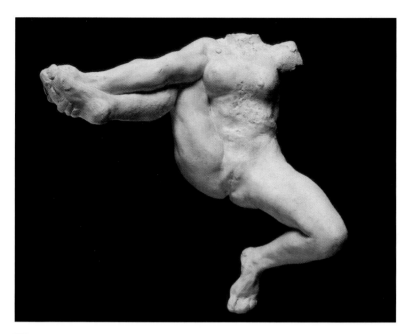

■ Erotica

The latter half of the nineteenth century saw a flowering of literature devoted to erotic or pornographic subjects—including well-written works by respected authors—and the creation of Gustave Courbet's famous and controversial painting *The Origin of the World* (1866), a close-up of a female pudendum. Rodin's erotic pictures were very daring, but since they were never made public, they did not add to Rodin's already considerable reputation for scandal.* These erotic drawings represented the pleasure of capturing on paper what he could not in real life, and were the complete opposite to his persona of the gallant society sculptor.

Rodin was in love with womanhood and for him, more than for any other artist, genitalia represent a pure image of desire. The artist-voyeur is seized and fascinated by this fragment of the female form, symbolic of the woman as a whole: "A bit of nature is shown, a strip of flesh appears and this shred of truth gives the whole truth, allowing us to rise with one bound up to the absolute principle of things." In his veneration for nature,* the sculptor found a reverence for the female pudendum.

Rodin saw but one step between the movement* of the line of the body as a whole, the imperceptible vibration of the flesh, and the absolutely immobile pubis, the origin of the world. Rodin always showed the greatest respect for the subject—because the works themselves gaze back at the spectator-voyeur. Like so many of his drawings of women,* his *Iris* is faceless, her genitals exposed. In a different version, she is presented vertically, gazing at the viewers with her pubis. The exact equivalence of her regard and ours creates the necessary distance. MPD

Iris, Messenger of the Gods, c. 1890–91, plaster, h. 16 ins (41.5 cm). Musée Rodin, Paris/Meudon.

Henry Becque, 1883, dry-point engraving touched up with black ink, 6 x 9 ins (15.7 x 23 cm). Musée Rodin, Paris.

53

■ EXHIBITIONS: RODIN ON DISPLAY

An exhibition is a chance for the artist to show the fruit of his labor, the finished creation, which comes into existence as a work of art only when presented to the public. It was not until 1871 that Rodin took part in his first exhibition, not in Paris but in Belgium.* Such exhibitions in general, and the Paris Salon in particular, were more than just a means of acquiring public acclaim, they were also an important way of obtaining the commissions that were a vital contribution to most artists' livelihoods. From his return to Paris, in autumn 1877, Rodin showed regularly at the Salon until 1888, one year before the Société Nationale des Beaux-Arts [National Society of Fine Art] began a rival exhibition, called the Secession. Rodin actively supported this new initiative, which rejected the narrow-minded attitude of the official Salon. Its lead was followed throughout Europe, uniting artists in a rejection of the classical, academic style; the Munich Secession was founded in 1892, and the Libre Esthétique [Free Aesthetic] show was first held in Brussels in 1893. Two shows in particular marked turning points in Rodin's career—his joint show with Monet at the Galérie Georges Petit in 1889 and a group show held in Geneva in 1896, which also featured works by Puvis de Chavannes and Carrière.

It was not until 1899, when he was fifty-nine, that Rodin had his first major solo exhibition. In fact, the event was planned to be a joint show with his good friend Puvis de Chavannes, a painter, but the latter's sudden death meant Rodin's works alone were shown. He chose to exhibit a large number of plaster* figures at four sites—Brussels, Rotterdam, Amsterdam, and The Hague. The show was a practice run for the major retrospective of his work that took place the following year in a special pavilion at Place de l'Alma in Paris, on the fringes of the World's Fair. The sculptor's early works, such as *The Bronze Age*, were placed next to more artistically developed or more daring pieces such as the *Monument to the Burghers of Calais* and *The Gates of Hell*—with most of the figures removed—and controversial sculptures such as his monumental statue of Balzac. He also showed a large number of small plaster pieces, brand-new assemblages* straight from his studio.

The success of this exhibition prompted Rodin to participate in similar shows in Prague in 1902 and in Düsseldorf in 1904. He also frequently lent pieces to museums and exhibitions both in France and abroad. HM

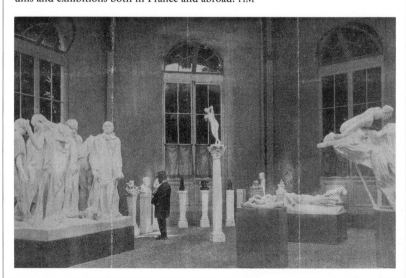

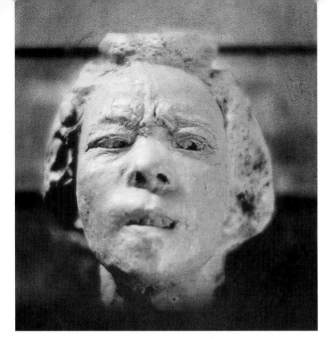

Mask of Hanako, c. 1908. Photograph E. Steichen. Musée Rodin, Paris.

■ Exoticism

Exoticism was the leading trend of the 1900 World's Fair in Paris, from the staircases in the Cambodian pavilion to the dances* of the Japanese star Sadda Yacco, showing how the tastes of the era yielded to the rather superficial seduction of novel forms and designs. Yet we find no trace of the influence of this style in Rodin's work. His engagement with the Orient came about through his genuine desire to know its people, sharpened by his appreciation of the unusual and the unknown.

Rodin had quite an impressive collection* of *objets d'art* from the Far East, including prints by Hokusai, Hiroshige, and Utamaro, stencils, netsukes, ceramics, masks, incense burners, miniatures, and wood carvings. Visitors to the Villa des Brillants were greeted by the sight of a giant Buddha from his collection. What interested him in particular in this piece was not its artistic qualities, but rather its formal characteristics as a piece of sculpture.

In 1906, a troupe of Royal Cambodian dancers came to France. Rodin, ever the keen-eyed observer of movement,* was thrilled by the graceful, sweeping gestures of the women and the extreme arching of their fingers. He saw in it "the very principles of the art of antiquity." He met the Japanese dancer Hanako the same year, and was fascinated by the sheer expressiveness of her face: he sculpted fifty-three portraits* of her. When, in 1914, he planned to work on "a new mask of her... a mask of her dying," it was with the wish to begin studying a new expression of traditional Japanese theatre. For Rodin, Hanako and the Cambodian women—and beyond them, the whole of the Far East—represented an opportunity to enrich his knowledge of forms and interior expression.

Rodin devoted his life as an artist to questioning the aptness of his creations' lines. Paradoxically, it was in his passion for civilizations separated by great distances of time* and space— ancient Greece and those of the Orient—that he began to find the glimmer of an answer. MPD

The Rodin Exhibition at the Pavilion on Place de l'Alma in 1900. *La Vie Illustrée*, December 21, 1900.

Family

There is a deep sense of mystery surrounding Rodin's links both to his own parents and family, and to the family he never wished to found for himself.

Rodin's family background was modest. His parents taught him the strengths of willpower and work,* humility, and a love of order. His father, Jean-Baptiste, passed on to his son his own idea of manly qualities, determination and energy. To the very end of his life, Rodin professed great respect for his father, who always actively supported him. We know little of his mother, who seems to have been a pious, timid, and rather serious woman.

His relationship with his elder sister, Maria, was characterized by great affection, tempered by her authority over him, which he occasionally translated into feelings of guilt, as when in 1861, he could not bring himself to leave the family home. Maria eventually turned her back on the family to become a nun, but died a few months later, plunging her brother into

Rodin and Rose Beuret in the Garden at Meudon, March 25, 1916. Photograph Migricoly (?). Musée Rodin, Paris.

deep despair. He had already experienced the loss of a younger sister, though he never spoke of this first death to anyone.

In 1864, Rodin met the woman who was to become his life-long companion, Rose Beuret. The couple met in the Gobelins quarter in Paris, where Rodin was working on the façade of the theatre. Rose became his first model,* and despite her justifiable jealousy of his infidelities, she remained devoted to him. The couple had a son in 1866; he was given his father's first name and his mother's surname. Auguste Beuret is a rather mysterious figure, but those who knew him described him as undisciplined and good for nothing. Following the example of his own father, Rodin attempted to give his son an appetite for drawing and engraving. However, Auguste Beuret was deeply hurt by what he saw as Rodin's rejection of him, and spent most of his life estranged from his father. Towards the end of his life, Rodin seems to have been afflicted by remorse at this state of affairs. He at last sent for his son, who came to live at the Villa des Brillants at the outbreak of the First World War, and he finally married the faithful Rose in 1917, a few weeks before her death. MPD

Fatherhood

In Rodin's work, the theme of love—or the lack of love—for children leading to tragedy is recurrent, in particular in his numerous cut-away drawings* inspired by Dante's *Divine Comedy.* The pictures show characters, of indeterminate gender, represented with their offspring, like distorted versions of more traditional images of motherhood. In some, Rodin clarifies

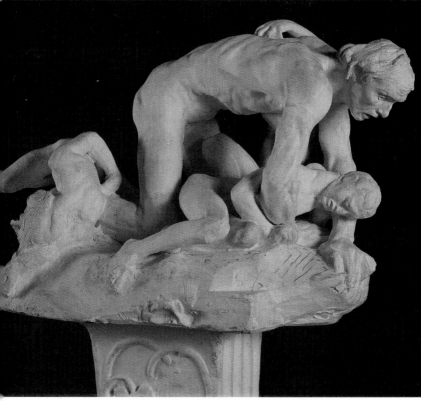

the gender of the characters, labeling the works *Medea, Niobe, Ugolino,* and so forth. The common link is the hideous fate of the children in the stories alluded to in these titles*: Medea murders her own children; Niobe's are killed by the arrows of Apollo and Artemis; and Ugolino, condemned to death by starvation with his family, devoured his offspring. Many of the drawings illustrate one or other of these legends.

Sometimes, Rodin was extremely precise in his commentaries: *Ugolino's Cruel Feast* is annotated with the words of the children to their father, taken from Dante's text: "Take back this flesh that you gave us." All these drawings are united by the seated position of the figures, the head* portrayed in profile,* and the ambiguity of the emotions—are the encircling arms protective or destructive?—that connect the adults and children. Other pictures are closer to a male Pietàs, showing a cut-away of a child or adolescent lying on the father's lap like the image of the death* of Christ. There is no hint of sensuality in these couples,* nor of the pity or piety suggested by the theme of the Pietà. The most unsettling of these images of fatherhood is the pitiful, crawling *Ugolino* (c. 1881), in which the tension between love and violence reaches a paroxysm.

We can never really know how far this reflected Rodin's own idea of being a father. However, we do know that he never officially recognized his son, Auguste Beuret. Beuret was lacking in any artistic talent, inherited nothing from his father, and died, alone and in poverty, in 1934. CBU

Ugolino on Top of a Pillar, c. 1881, plaster, h. 16 ins (41.5 cm). Musée Rodin, Paris.

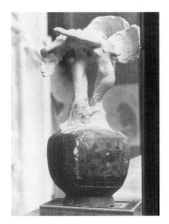

■ Flight

In Rodin's works, flight is more than a simple gesture. It is a movement* that seizes the whole figure, imprints its being, and takes it beyond its bodily limits. It is the counterpoint to the risk of imbalance* and falling; the piece attempts to escape the implacable law of gravity by an impossible desire to soar heavenwards. Several of Rodin's figures have wings, and he produced many small or medium-sized studies of such figures, like the *Spirit* or *Pas de Deux*. This last work consists of a double *Dance Movement*, and was sometimes placed on an ovoid support, to accentuate its fragile stability. The figures represented in the *Dance Movements* seem to be taking flight, as opposed to the *Falling Movements*. One of the most striking examples of this is the group known as the *Benedictions* or *Flight*, today in the Mirbeau collection. This small winged group was originally designed to be placed atop the *Tower of Labor*. Rodin himself described the work as a biplane: "the air flashes at the tips of the wings, at the tips of the fingers. Whichever side I look from, the group always seems to be

soaring above the column, harmoniously, like light."

Rodin felt a great affinity with aviators, calling them "brothers of artists," creators, heroes, "demigods," wholeheartedly devoted to the conquest of the skies: "Where the mechanics talk of a machine, they talk of their bird, just as real sculptors speak of the substance of their marble." In 1908, Rodin took part in judging a competition to design a cup for the Michelin aviation company, and in 1912, when the French government opened a subscription to buy an airplane, he donated his *Call to Arms*, depicting a dying soldier in the arms of a winged spirit. Whenever an airplane passed overhead, Rodin gave utterance to his passion for the theme of flight, murmuring "Da Vinci's dream is passing overhead!". HM

■ Fragmentation

"In art, one must know how to make sacrifices." This thought —eventually applied to his own work—was prompted by Rodin's observations of the sculptures of antiquity he admired so much, which often survive only as fragments.

The *Shades* lost a hand* before 1886; however, it was with four spectacular pieces—*Meditation, The Tragic Muse, Iris*, and *The Earth*—that a new tendency became apparent in Rodin's oeuvre, roughly from 1895 onwards. He stripped his work of everything that seemed superfluous or unnecessary, in an attempt to lay bare the sculpture's very essence. Although to the uninitiated the works appear incomplete, for the artist, they are whole and finished. Rilke wrote: "The same goes for Rodin's statues without arms; nothing necessary

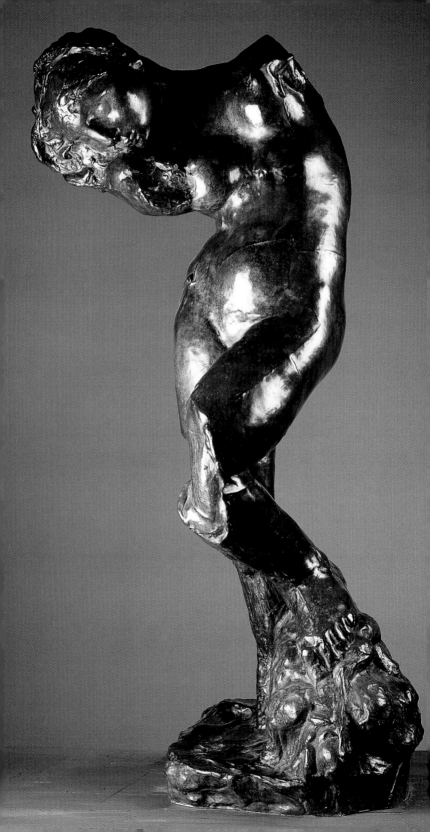

is missing. You stand before them as before a complete whole which refuses all complements." It was not a question of an inability to complete a sculpture. He had given sufficient proof of his mastery of the human form in *The Bronze Age* or *Saint John the Baptist*; now his powerful artistic will wanted to pierce through to the essence of the figure and make this essence itself the subject of his work.

This notion of fragmentation is behind the large number of male and female torsos he created, where the absence of limbs underlines the inner strength that pours forth from these fragmented bodies, a reminder of the extraordinary boldness of his *Iris*. It spurred his efforts to dislocate the human form, to produce torsos, heads,* arms, and legs, with their own vital spark, independent of the body. Through the process of assemblage,* Rodin recomposed these fragments into bodies, providing the amputated torsos with limbs. In so doing, he was motivated not so much by a desire to produce works that were true to life as by a compulsion to create and combine new forms. HM

▆ Fragments

Rodin called his sculptures of different parts of the body *abattis*—fragments—and considered each one charged with the spark of life. The artistic process involved in the sculpture of these *abattis* was very closely linked to his techniques of assemblage* and fragmentation.* Rodin reworked certain elements from some of his well-known sculptures, simply because he liked them so much that he wanted to repeat them and thus build a repertory of forms to draw on. This is the case of the head of the *Slavic Woman* and the *Female Sphinx*, or the arm of *Meditation*, bent towards the shoulder with sometimes a rather forced articulation* of the joint.

Modeled or molded in series, Rodin's *abattis* were designed as independent elements, and were destined to complete torsos or unfinished* human figures. The British painter Sir Gerald Kelly wrote that the *abattis* were small—only half life-size—and that Rodin never discarded a single one, putting them away in special shallow drawers that had to be opened with a great deal of care so the pieces did not damage each

Drawer Full of Abattis, 7 x 10 ins (19.7 x 26.5 cm). Photograph L. Iselin. Musée Rodin, Paris.

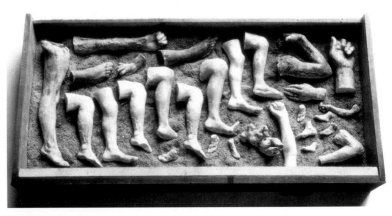

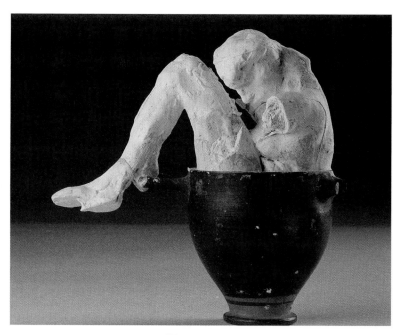

other; he also wrote of how much he loved looking at the collection of tiny hands. Open hands, clenched fists, bent, stretched, or twisted arms, arched feet, legs cut off at the knee, faces with closed eyes and barely sketched features—all these fragments were brought together in one superb collection of human forms that Rodin was able to draw on rapidly, producing new effects. In *The Hand of the Devil*, for instance, the *Small Female Torso* has a pair of arms in the place of legs.

Rodin's use of fragmentation* lead him towards an artistic process that was almost abstract in nature. The fragment became a finished, complete work of art in its own right, stripped of all superfluity. Rodin's use of *abattis* gave him the means to compose and combine the elements of his artistic vision as each individual piece required. HM

Greece

All Rodin knew of Greece were its ancient sculptures—the masterpieces he had seen in the Louvre, Roman copies in Italy,* or pieces from his own collection.* In 1904, he published a text that reflected his great personal interest in the subject, entitled *The Lesson of Antiquity*. In the article, he contrasted artificiality of the "antique style"—in other words, the servile imitation of an ideal model—and the intrinsic truth of the "antique model," where nature* is an integral part of the work's conception, a combination of the efforts of the sculptor, the qualities of the stone, and the play of light. "The Greeks studied nature a great deal, and their beauty comes from these studies, not from some ideal beauty." For Rodin, even fragments of antique statues had this magical quality.

From 1900, Rodin's works not only echo elements of Greek art

Assemblage: Female Nude Seated in a Pot, c. 1900, plaster and antique pot, h. 6 ins (17.3 cm). Musée Rodin, Paris/Meudon.

(the muse in the *Monument to Whistler* is a direct reference to the *Venus de Milo*), but also includes elements borrowed from ancient sculptures in his own collection.* A case in point is the funeral cask carried by this same muse, which is a cast taken from a small Roman altar in Rodin's collection. Another example is to be found in the *Pallas in the Parthenon* (in fact, the piece is a portrait* of Mrs. Russell, the wife of an Australian painter): he made the top of the head rather flat to be able to place a miniature antique temple on it. In some assemblages,* Rodin put his own plaster* figurines into antique vases and dishes from his collection.

Woman like a Vase, pencil and watercolor on paper, 19 x 12 ins (49.2 x 32.3 cm). Musée Rodin, Paris.

He also produced a number of drawings* with simple, clear lines and a brown ochre wash to give a terracotta effect; he called these his Greek *instantané* sketches. A certain number of these pictures are of kneeling female nudes facing the artist: their silhouettes recall the shape of antique vases. This was perhaps the final lesson that the art of antiquity had in store for Rodin: a permanent metamorphosis of aspects and meanings, like a still life composition. CBU

Grey

With his black* drawings of the 1880s, Rodin created a very private and personal form of expression. Later, around 1900, he chose to work with a lighter, more colorful palette, and his favorite subject became the female form. This stage could be called his grey period in drawing. In around 1910, he began to draw exclusively in pencil, abandoning both ink and watercolor. Dark or light grey, soft, hard, diffuse or sharply and strongly delineated, Rodin used many different styles and shades of grey. He used grey first of all for its clear tone, forming a background against which touches of black in soft lead pencil stood out clearly, giving the drawings an extremely graphic quality.

He also used grey for hatching, and smudged shadows with a handkerchief to obtain softer, more realistic effects. At the same time, the eraser became an indispensable tool, not just for rubbing out, but to "draw" sharp, clean lines in blocks of pencil shading. By attenuating the effects of smudging, he was able to use an eraser to create effects of light and relief.

At this time, Rodin had the habit of sketching his female models* rapidly from life and was more interested in depicting the form than the movement* of their bodies. Once he had finished the initial sketch, he took the time* to go over a detail of the model's hair or the fall of a piece of cloth with clean, pronounced lines that play with the contrast of the cloudy, smudged blocks of shading. In sculpture, Rodin was attentive to the various effects he could obtain by

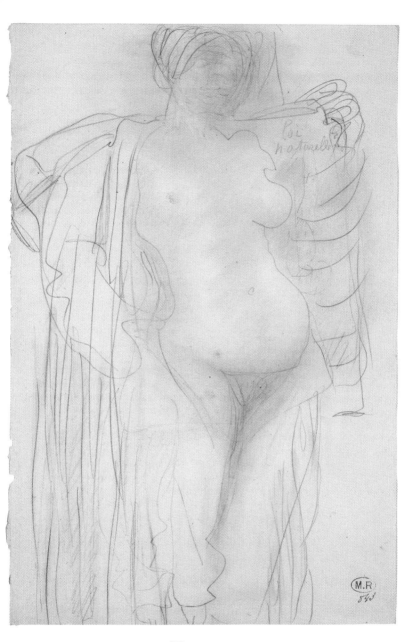

different treatments of the marble.* For example, he might choose to present a high polish to the face and body with precise, detailed grooves for the hair, and contrast this with the unfinished* aspect of the stone. This is exactly the procedure Rodin used in his "grey" drawings. CBU

■ Hands

In Rodin's oeuvre, hands are both a means of expression and a symbol. They are the essence of the gesture, as in *Saint John the Baptist*, where one hand underlines the importance of the saint's words, and the other points to the ground. The hands of the *Burghers of Calais*,

Natural Law, c. 1900, pencil drawing on paper, 12 x 8 ins (30.9 x 20.3 cm). Musée Rodin, Paris.

*Hand Hanging
From the Wall.*
Photograph
D. Freuler.
Musée Rodin,
Paris.

and are possessed of their own innate meaning. In their various forms, they are put on display and become an integral part of different compositions, bringing their own language to the work as a whole. In *The Secret*, Rodin placed two identical right hands facing each other, holding a small casket. Similarly, in *The Cathedral*, two right hands are brought together to create a new space that resembles a ribbed vault.

In Rodin's works, hands are often associated with portraits,* giving the faces a certain depth and mystery that is almost allegorical. They highlight the gentleness of the face in the busts of Madame Fenaille or Eve Fairfax, for example, or sometimes a certain strange quality as in *Camille Claudel and the hand of Pierre de Wissant*. Rodin's own hand was cast shortly before he died. A small female torso was placed between the fingers, symbolizing Rodin's entire creative output. HM

especially the figures of Jean de Fiennes and Pierre de Wissant, are open in a gesture of abnegation and sacrifice. Rodin reused the model of Pierre de Wissant's hand for *The Hand of God*.

Separated from the body, the hands become either fragments* or studies, and even deserve to be called monuments in their own right. Rilke wrote: "In Rodin's oeuvre there are hands, independent and small hands, which, although they do not belong to a body, are nonetheless alive. Hands that rise up, irritated and bad-tempered, hands that seem to bark with their five fingers bristling, like the five maws of a dog of Hell. Hands that walk, sleep, hands that are just waking up...."

Although they may appear to be fragments, these hands are always complete sculptures in their own right, with astonishingly powerful expressive capacities. As "fragments of bodies," they form a whole,

▮ Heads

"It is not Baudelaire, but a head of Baudelaire," Rodin said of one of his sculptures: a simple, round head without a neck, with "an enormous forehead, rounded at the temples, covered in bumps, tormented." The piece never made it past the stage of a study for a planned monument to the author of *The Flowers of Evil*. In Rodin's oeuvre, the head is an independent whole, more so than any other part of the body, because it is naturally expressive.

He created, for example, numerous variations* on the head of the Japanese dancer Hanako, in a range of forms and materials*—clay, plaster,*

bronze,* and molten glass, though none in marble,* the usual material for a sculpted portrait.* It is believed that Rodin even considered using one of the versions as the basis for a bust of Beethoven.

When creating such studies, Rodin resolutely turned his back on the model* who sat for him, producing instead reusable heads designed to typify certain facial expressions. When he first saw Hanako performing *Death of a Geisha* on stage in Marseille, he was intrigued by the terrible beauty of her expression, which reminded him of the mask of tragedy. He was also fascinated by the expressive qualities of other faces, which he used as models in works such as *The Damned* and *The Gates of Hell.* Some of these highly expressive faces became the subject of works in their own right, like the *Small Head with a Snub Nose,* the *Laughing Head,* or the *Small Head of a Damned Woman* (also known as the *Street Crier* or *Head of a Street Urchin*). What gave some of these heads their sheer expressive power was the process of mechanical enlargement. The most impressive of all from this point of view is the gigantic version of the *Head of Iris.* Swollen, bruised, covered in irregularities, grooves, and bumps, with a thousand details testifying to the humanity of the subject, the sculpture is a

Iris (mask), before 1894, plaster, h. 9 ins (22.5 cm). Musée Rodin, Paris/Meudon.

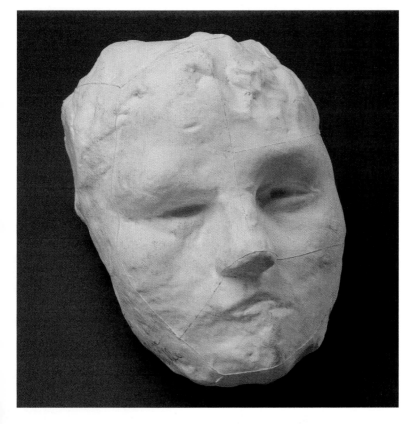

■ Hell
Dante's dream

Rilke wrote: "Rodin created these gestures ...
He gave hundreds and hundreds of figures
barely bigger than his hands lives filled with
passions, the flowering of all the pleasures,
and the burden of all the vices. He created
bodies that touch and grip like beasts biting
each other, yet which plunge like inanimate
objects into the abyss; bodies which listened
like faces and which swung like arms prepar-
ing to throw something; chains of bodies,
garlands and twining stems, and heavy
bunches of human forms like grapes, in
which the sweet sap of sin rose from the roots
of pain."

The Gates of Hell, designed for a decorative
arts museum that ultimately never opened,
was the piece that Rodin came back to all his
life. For him, it was a crucial inquiry into the
nature of human passions as described by
Dante in his *Inferno*. On the threshold of this
terrifying universe, the *Three Shades* warn the
lost souls—and the onlooker—with the terri-
ble words *"Lasciate ogni speranza voi
ch'entrate"* (Abandon all hope, ye who enter
here). *The Thinker*, the image of the poet-cre-
ator of this universe, is placed at the mid-
point of the tympanum, dominating the dark,
tormented world he created, filled with indi-
vidual figures and groups like *Fugit Amor* and
Paolo and Francesca, whose desperate embrace
is but a reminder of the impossibility of being
and the inevitability of their horrible destiny.
Ugolino, on all fours like an animal, crawls
over the bodies of his dying children. These
are the wandering, lost souls that Dante and
Virgil meet in the circles of the underworld.
Rodin dealt with each subject individually,
and the elements of the *Gates* also have an
independent existence beyond this work.

Thus *The Gates of Hell* proved to be a rich
seam for Rodin, the source of a host of images
of lost souls, which the sculptor did not
hesitate to reuse in other works. HM

The Gates of Hell (detail), 1889–90, bronze,
h. 20 ft 3 ins (6.18 m). Musée Rodin, Paris.

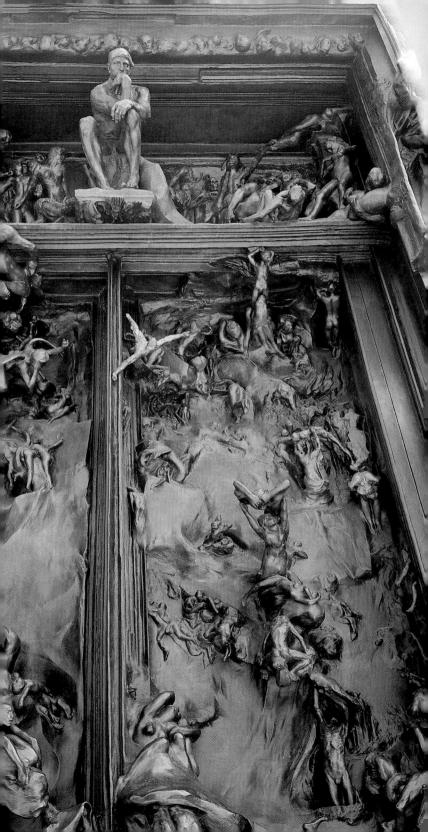

The Centauress,
c. 1887–89,
plaster, h. 18 ins
(46.2 cm).
Musée Rodin,
Paris/Meudon.

Le Guignon,
(Bad Luck),
1887–88,
brush and ink
illustration to
accompany a
poem in Charles
Baudelaire's
Les Fleurs du Mal,
Paris, 1857, p. 35.

■ Hybrids

Rodin was familiar with the phenomenon of metamorphosis. As an artist, he experienced the daily changes he wrought in his own unfinished* works. Intellectually, he was fascinated by the notion of metamorphosis as a manifestation of the inner life of things. Hybrids, the results of a mutation, are to be found throughout his oeuvre, an interest that arose from his parallel reading of two books,* Dante's *Inferno* and Ovid's *Metamorphoses.*

The centaur particularly fascinated Rodin, the duality of its man-horse body suggesting to him the ambiguity of human passions. It appears in his drawings* and on his vases, and, echoing the twelfth canto of the *Inferno* where Dante discovers the centaurs guarding the pit, Rodin apparently planned to place them framing the doors of his *Gates of Hell.* Only one centaur remains in the piece, however, trapped in the architecture* of the door like the hybrid creatures depicted on the pilasters of Chartres cathedral. For Rodin, what better opportunity could there be to study the richness of life than through

centaurs and other mythological hybrids, such as minotaurs, sirens, satyrs, and fauns, their bodies writhing together in mad orgies, in violent abduction, or in tender yet inhuman images of fatherhood*?

Rodin breathed fresh life into these creatures. He said of his *Centauress*, created in 1889 from an assemblage* of the horse in the *Monument to General Lynch* and a female torso: "I wanted to represent the soul ridding itself of matter." In Rodin's works, the hybrid is omnipresent, the result of his research into the fusion of bodies. The master of transplantation, he combined elements to create entirely new hybrids. Beyond the requirements of figurative art, thanks to the process of assemblage, the hybrid is at the center of Rodin's creativity. MPD

■ ILLUSTRATION
Beyond a literal reading

The titles* of many of Rodin's creations are taken from literary works. However, with the possible exception of *I Am Beautiful,* none of these pieces actually illustrates a text, other than in the sense Rodin wrote of in 1883: "At the moment my drawings are something like an illustration of Dante from a point of view of sculptural expression." Some of the books* he read thus became a source of ideas for further artistic research as well as the object of a work.

Rodin only ever illustrated books if he was specifically requested to do so, which happened rarely. At the end of 1887, he decorated the editor Paul Gallimard's copy of Baudelaire's 1857 collection *The Flowers of Evil* with twenty-six ink drawings.* In this unique book we find the close hatching that Rodin often used for drawing his own sculptures, as well as the artist's fondness for the black* style used in his drawings of hell.* In 1899, Rodin signed a contract with Ambroise Vollard to produce the illustrations for a luxury edition of the *The Torture Garden* by his "dearest friend," Octave Mirbeau, to be printed in 1902.

These two books represent twin poles, their illustrations clearly indicating the development of Rodin's drawing technique: the enlarged format, the lighter colors, the simplification of the lines. Other significant milestones include his illustrations for Emile Bergerat's *Enguerrande* in 1884, the *Poems* of Humilis in 1910, Ovid's *Metamorphoses*, and Emile Zola's *Germinal.*

On a more personal level, Rodin also liked to decorate the texts written by his friends, not with illustrations as such, but with ornamentation for the frontispiece, as an expression of his admiration. MPD

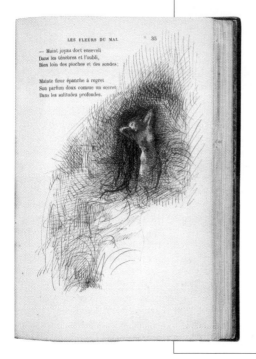

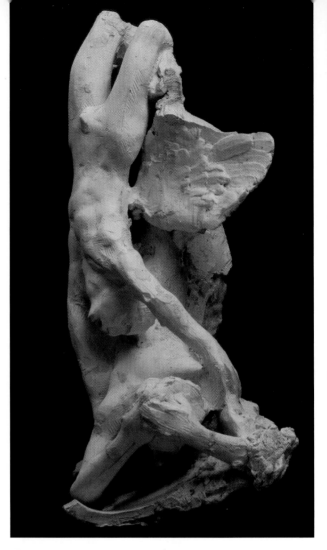

The Fall of Icarus,
before 1900,
plaster,
h. 18 ins (47 cm).
Musée Rodin,
Paris/Meudon.

◼ Imbalance

Rodin's figures are pushed to the extreme limits of their possibilities; they are pushed beyond the point of equilibrium, towards an inevitable fall. The *Crouching Woman* represents this kind of tension, which distends and ruptures in the *Falling Man*. The numerous winged figures among Rodin's works also bear witness to this; many of them seem to be tumbling down from their soaring flight, such as the *Fall of an Angel*, the *Falling Angels*, the *Fall of Icarus*, or *The Illusion, Sister of Icarus*, which Rainer Maria Rilke called a "dazzling transformation of an object into a long, disarmed fall."

Even *The Gates of Hell* could be said to tell the story of a great, predestined fall—the fall of man, the sinner. The figures that haunt the world depicted on the *Gates* seem to be plunging towards the abyss of suffering and desolation that covers the bronze* doors. The *Falling Man* tries in vain to clutch hold of the tympanum, and only just manages to keep his balance when he is depicted bearing in his arms the *Crouching Woman*

in the group of figures known as *I Am Beautiful*. The wings of the small *Blessing Spirit* are not enough to save the figure from the turmoil, while *Mercury*, the messenger between mankind and the gods, is represented on the right door, plunging downwards, his arms spread wide in a powerful gesture of impotence and despair.

There is a tension in these works that pushes them beyond the boundary of stability. The *Spirit of Eternal Rest*, a hymn to the talent of Puvis de Chavannes as part of the commemorative monument dedicated to the artist's memory, is depicted as leaning heavily towards a bust of the painter. The crackle effect at the statue's waist adds to the effect. Pulled downwards by the burden and inevitability of fate, Rodin's *Falling Movements* are representative of the same theme. They echo the movement of the series devoted to flight* and the *Dance Movements*, which seem to challenge the very laws of gravity. HM

■ Inner Life

Rodin's entire oeuvre is filled with a great sense of tension which makes his figures arch* and brings astonishing vigor to the angles and articulations* of every sculpture. It may have been his study of Michelangelo in Florence in 1876 that prompted Rodin to seek to bring out this latent power in his sculptures, which were so often closed in on themselves.

The way Rodin's figures seem to rely on inner resources is prefigured in pieces like *Eve*, the concentration of *The Thinker,* or the twisted form of *The Shade*. These figures all turn their heads* away, seemingly oblivious to the viewer; only their

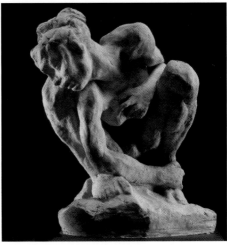

backs face the spectator. While the women in Rodin's drawings* are hunched over in closed cells, the artist was equally capable of deftly inscribing the body like an oval in the constrained geometry of an imaginary architecture,* as in the representation of roman canopies he admired, or his *Three Shades*, which he liked to interpret as an architectural "console."

Yet the viewer's vision, supposedly drawn to the center by this movement* towards the interior, is in fact drawn to the extremities of the piece by the rhythm of the limbs, the heavy stone of the *Caryatid*, or the hand* trying

Crouching Woman, c. 1881–82, terracotta, h. 10 ins (25.5 cm). Musée Rodin, Paris/Meudon.

Woman Combing Her Hair, before 1900, plaster, h. 10 ins (25.7 cm). Musée Rodin, Paris/Meudon.

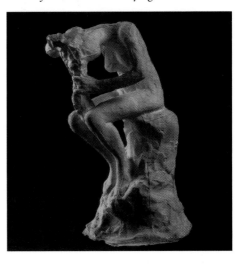

in vain to escape the vegetable magma of *Death*. The play of orthogonal lines in the *Woman Combing her Hair* finally manages to pierce the walls of the cell, creating an unsettling circular movement in which nothing draws and holds the viewer's attention. It is as if the inner life of these figures is not enough: the limbs fly out like arrows towards the edges of the solid block (*The Prophetess, Creation*). The tension is too strong.

For Rodin, the body is "the amphora that contains within its flanks the life of the future." Movement is immanent to the human form, because, by the very fact of its existence, it is the manifestation of life, even in pieces depicting the strength of man's internal state, movement is omnipresent. MPD

▦ Installation

In the modern sense of the term, an art installation is the staged presentation of objects removed from their ordinary context to form new and often ephemeral composition, in which the objects are appropriated and their use changed.

The *Monument to Puvis de Chavannes* is the first of Rodin's works to put this procedure into practice, although it was not designed to be an ephemeral piece. Commissioned in 1899 to honor the memory of the artist, a close friend of Rodin, the monument is built around the figure of the *Spirit of Eternal Rest*, inspired by a work of antiquity on display in the Louvre. The spirit is leaning towards the *Bust of Puvis*, a piece Rodin had completed a

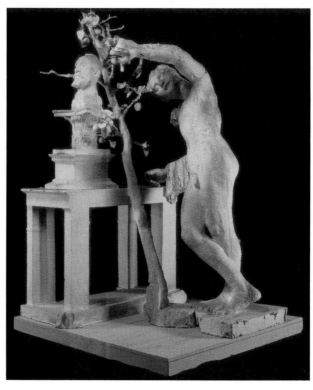

few years earlier, in 1890. The bust is placed on top of a column with a Corinthian capital, which in turn stands on a table. The figures are linked by an apple tree with fruit (cast from life) hanging from every branch. This work consists in the accumulation of elements that either already existed, or that were cast specially for the piece. There was no obvious link between the various elements, which were created using different materials.* Rodin's artistic language in this work goes much further than the traditional uses of allegory. He explores new paths, ridding the work of usual elements such as the laurels crowning the brow of the artist, replacing them with objects that he endows with a particular significance. His aim was not so much to describe the artist as to suggest his talent obliquely. The presentation of the various elements is scrupulously planned. The fruits and the tree that lean so naturally to one side, the table—all ordinary, everyday objects—are stripped of their basic functions in order to serve as components of the installation. In Giacometti's *Surrealist Table* (1933) it is impossible to overlook the clear allusion to Rodin's *Monument to Puvis de Chavannes*, a magnificent work conceived and sculpted as one gigantic assemblage.* HM

▪ Italy

Rodin's first visited Italy in 1876, when he was already thirty-six years old. He knew no one, and he envisaged his journey as an opportunity to study Italian art free from any exterior influence. The experience proved to be a vital one, as indicated by the sketchbooks that he brought back to France at the end of his stay.

Rodin felt the need to confront the achievements of the old masters such as Donatello (*Mary Magdelen* and *Gattamelata*), and above all Michelangelo, whose works—such as the *Tomb of the Medicis* and *Moses*—had a profound and lasting impact on him. In his youth,* Rodin had already been struck by the power of Michelangelo's *Slaves* in the Louvre and their influence on *The Bronze Age* (1877) is evident. From the outset, he had a romantic idea of Michelangelo: "If we are looking for Michelangelo's spiritual meaning, we realize that his statues express the way the being painfully turns in on itself, the unsettling energy, the desire to act without hope of success, and finally the martyrdom of the creature tormented by aspirations beyond its reach."

The sculptures that Rodin produced immediately after returning to Paris are marked by a *contrapposto* that Rodin had noted in, among other works, *Day* and *Night* in San Lorenzo in Florence. But the definitive aesthetic revelation came when he saw one of Michelangelo's later works, the *Pietà*, in the Duomo in Florence. This *Pietà* depicts Christ borne by three figures, and aspects of his twisted body, profile,* and folded leg are to be found in the wounded soldier in *The Call to Arms* (1879), as well as in the figure of Adam exhibited at the 1881 Salon with the title* *The Creation of Man*. This sculpture also echoes the gesture of Michelangelo's *Adam* on the ceiling of the Sistine Chapel, but its index finger, instead of touching the hand of God, points to the earth.

Monument to Puvis de Chavannes, c. 1901–02, plaster, h. 8 ft 6 ins (2.60 m). Musée Rodin, Paris/Meudon.

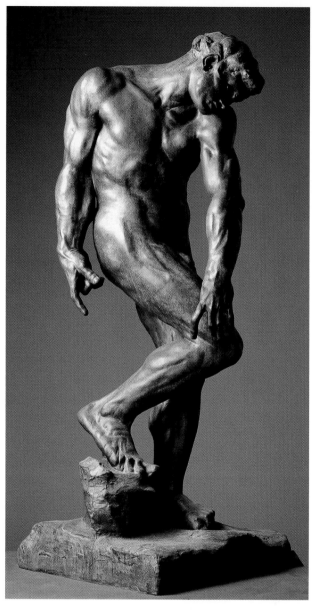

Adam,
1880–81,
bronze,
h. 6 ft 5 ins
(1.97 m).
Musée Rodin,
Paris.

Rodin, who never worked with hammer and chisel himself, preferring to mold or cast his pieces, was also deeply impressed by the way Michelangelo hewed blocks of marble. Some sixty years later, he was to forge his own (slightly misleading) image for posterity by posing in front of a block of marble for Sacha Guitry's film *Those at our House*. CBU

Marble

The sculptor's hands are the tools of his genius. However, we all too easily forget that in the nineteenth century, it was rare for the artist himself to use a hammer and chisel on the raw material of the final sculpture. In general, he would call on the services of an assistant sculptor, who would hew the marble to

produce a work identical to the model supplied by the artist. These assistants might themselves be excellent sculptors.

Rodin would hand a sketch over to his assistants, often a design for an assemblage,* indicating the general outline of the final result he wanted to see. There had to be a relationship of complete trust between the sculptor and the assistants, particularly where interpretation of the model was called for. Of course, the sculptor would follow the progress of the work at every stage, and the assistants proved their artistic sensibility in the exactness of their translation of the sculptor's original vision.

The example of *Thought* (1893–95), based on the features of Camille Claudel, provides a perfect illustration of the role of chance* and artistic liberty in the relationship between the sculptor and his assistant.

Just as his assistant Victor Peter set to work on the neck ruff that was to frame the lower part of the face, Rodin decided he liked the effect of the head,* with its delicate features, emerging from the rough block of marble. He called on his assistant to stop, and the work remained as it was, unfinished.* Marble is a noble material,* one that allowed Rodin to illustrate his boundless admiration for Michelangelo and Carrière by the endless play of contrasts between carefully finished parts and those that were left rough, untouched. He did not hesitate to leave traces* of the work on the finished piece: sometimes nails used to indicate positioning in previous stages were deliberately left in the final marble version. Most of Rodin's masterpieces in marble were the result of commissions, which rose steadily after 1900. HM

Paolo and Francesca, 1905, marble, h. 31 ins (81 cm). Musée Rodin, Paris.

Sleep (scale model), terracotta, wax,
plaster, h. 18 ins (46 cm).
Musée Rodin, Paris.

Whatever material the artist chose—soft or hard, resistant or pliant—Rodin was an expert in using its particular qualities to bring out the best in each piece. He modeled clay directly and also used plaster,* as well as bronze* and marble,* which were worked by his assistants while he oversaw the procedure. Apart from these more traditional materials, Rodin also experimented with the new and unusual.

After 1900 in particular, he decided to return to his earlier works in a more systematic manner, applying various techniques such as assemblage* or changing the scale* of the work, or perhaps translating the piece into a different material so as to change its physical aspect.

With the help of Jean Cros, a master craftsman in glass, Rodin was able to introduce color into his sculpture by using molten glass, a fragile and precious material. For him, color summed up the memories of a lifetime, in works like *Portrait of Camille Claudel Wearing a Hat* or the masks of Hanako and Rose Beuret, which he cast "in the translucent material with the tones of living flesh, hardly paler than life and as if flushed by a touch of blood. ... It is like [the face] of a being that has been on the point of death and has returned to witness a second life...." Rodin also produced works in sandstone with the help of Jeanneney; he reproduced the *Bust of Jean d'Aire* and the monumental head* of his *Balzac* in this new material, which is highly fragile despite its solid appearance.

Rodin also worked with wax, modeling clay, and plastiline clay, which he used for modifications to his planned works and to highlight certain aspects of a model, as illustrated by the bust of *Clémenceau* or the scale model of *Sleep*, which combines several different materials: terracotta, plaster, modeling clay, and newspaper. Rodin enjoyed exploring the possibilities of the materials he used in these small scale models of two monumental works, which, in fact, were never produced as planned. The materials chosen for a sculpture played an important role in the composition of the work as a whole. Rodin suggested, for example, that the frame and crown of one version of *The Gates of Hell* should be in marble, while the two doors and the tympanum be in bronze. He also inquired into the cost of producing the various elements of his installation* *Monument to Puvis de Chavannes* in different materials. The plinth*, table, and capital were planned in stone, the apple tree in wrought iron, the bust of Puvis de Chavannes itself in bronze*, and the spirit watching over him in marble. HM

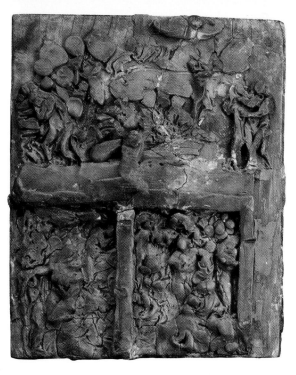

The Gates of Hell (second scale model), 1880, wax, 6 x 5 x 1 in (16.5 x 13.5 x 2.6 cm). Musée Rodin, Paris.

▨ Modeling

"When you moisten my figure, don't moisten it too much, or the legs will become too soft." "Be careful with the molds, my love, wrap them up well." Whenever he went away, Rodin gave careful instructions to Rose, who was left in charge of the studio.

The clay and plaster* he used to craft his models were the fundamental tools of his trade. Rodin did not carve or hew his sculptures, but rather produced a clay model which was then cast to give a plaster figure, which might later be reproduced in marble* or cast in bronze.* All his marble portraits* were originally crafted in clay, which is a more beautiful and subtler material,* allowing the sculptor to attain a finer level of detail.

As a raw material, clay could also be used for trying out ideas. The traditional tools for modeling clay—apart from the artist's own fingers, the most important of all—are the boasting chisel, used for flattening, smoothing, or making grooves in the clay, jointers, a steel wire for cutting lumps of clay from a block, and graters, which Rodin often used to wonderful artistic effect.

Most of Rodin's figures were first produced as small clay models. They were often then increased in size, with all the irregularities of the clay reproduced in the larger model, reflecting Rodin's interest in the effects produced by various materials* and the tactile qualities of each piece.

The power of Rodin's bronzes depends not only on their massive solidity, but also on the first outlines of the piece in the clay model. The final result varies a great deal depending on how wet the clay was to begin with, its ridges and bumps, the sharply defined contrasts between rough and smooth over the entire surface. Rodin wanted every figure he modeled to show these qualities; they are reminiscent not of smooth, stolid flesh, but of the vigor of life. CBU

■ MODELS
A passion for the human form

"There is no chaos in the human body, the model is the point of departure and end result of everything."

Rodin saw the bodies of his models in terms of light, lines, softness, and firmness of the profile.* Although he was trained in the art of drawing* from memory, he was aware that the memory "can never render the immediacy of life or the light of movement." As soon as his reputation was established, he began to work with the many people who came directly to the studio* hoping to sit for the master. He listed their names under M (for models) in his address book. Next to each name are a few brief notes in Rodin's writing: "very beautiful, like an antique: accept," "skinny, well-formed," or "short legs."

Working with live models required a high level of control over the eye and the hand,* which enabled the artist to capture the movements* of the model just as if he were taking written notes, with a great sense of freedom. Rodin loved women*— for whom he had "infinite admiration, a religious devotion"—and creating nudes.* Some of his most famous works were inspired by the bodies of his most outstanding models. Both *Saint John the Baptist* and *The Walking Man* were inspired by one Pignatelli. When Rodin had an idea for a piece and required a model to incarnate it, he did not hesitate to ask his sculptor friends for suggestions; he even asked people he met through chance* encounters to come and sit for him if they corresponded with his idea of how his sculpture should look. Thus the soldier Auguste Neyt posed for *The Bronze Age*, and the fairground strongman Caillou for *Adam*. To carry out his commissions in honor of artists and writers after their deaths, such as the monuments to Balzac and Baudelaire, Rodin even went so far as to scour the streets for lookalikes. In this way, he was magically able to turn the clock back and depict a living genius, for "in every model, there is the whole of nature." MPD

■ Monad

"Monad" is the term—or title*—Rodin used for his drawings* of female nudes* displaying their genitals. It is unlikely that Rodin was using this term in reference to Leibniz's theory of the most basic building blocks of life, as he did not possess any of the philosopher's works. He may instead have been using it in its original meaning of the perfect unity of Pythagorean thought, as he was familiar with Greek philosophy.

Some of these figures, sketched in pencil and with details picked out in watercolor, are positioned in an oval covered in a wash of very dilute watercolor, reminiscent of a bubble or an egg. Others are depicted with their legs wide open, while the rest of the body disappears to leave the viewer with the impression of a door. Apart from these works, Rodin also produced a number of detailed, close-up studies of female genitalia.

Rodin Working From a Female Model, Nude From the Waist Up, 1895. Photograph Duchene (?). Musée Rodin, Paris.

These curious "monads" are linked to another series of ideas that Rodin jotted in pencil on some of the works: "chimera-monad-before the Creation," "monad-spider-chaos-cup," "monad-rolling for centuries-chaos," or "monad-Venus rising from the waves-lust-octopus." The free association of ideas hinges around the central, primordial form, which itself can represent the void that filled the universe prior to the act of creation and the bringing forth of order from the chaos of Greek mythology, which is explicitly mentioned in several drawings. Finally, the concept of the monad refers to the obviously erotic nature of these drawings. The metaphor of the female genitals (*mona* in Italian) is omnipresent in Rodin's thought and work: as octopus, spider, or chimera, the object of fear and desire, balancing point and culminating point of the arch* of the legs, the curved bottom of the cup. CBU

Chaos,
pencil and
watercolor on
paper,
12 x 9 ins (32.7 x
25 cm). Musée
Rodin, Paris.

■ Movement

In 1878, Edward Muybridge presented the first photographs showing the movement of a galloping horse to the newspapers. The technique of chronophotography was soon to permit artists to realize their age-old dream of dividing movement up into a series of instants. When Muybridge published *Animal Locomotion* in 1887, Rodin took part in the subscription. By 1911, when Duchamp painted his first *Nude Descending a Staircase*, Rodin had already come to his own conclusion: "It is the artist who is truthful and the photography that lies; for in reality, time does not stop." He associated the translation of movement into a series of instants with the idea of metamorphosis, the "passage from one pose to another,"

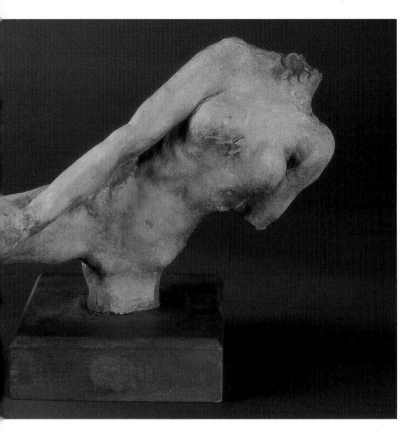

"*To seize that special gesture, in which the nature of a form is best revealed, to succeed in holding it, by translating not only the external movements, the visible manifestations, but the palpitation of thought or the sensation from which it grew, in sum, sculpture is only that, nothing more.*"

Rodin

Gabriel Mourey, "Auguste Rodin", in *La Revue Illustrée*, October 15, 1899.

telling "how imperceptibly the first glides to the second."

Rodin played with the idea of transition by displaying the various instants of a given gesture in one single sculpture, synchronizing instants of the gesture represented with the time* it took the viewer to follow the "movement" with his eyes. He linked the first and last instants of the gesture, as when he used numerous profiles* as the basis for the plans for a sculpture. Rodin was fascinated by the notion of the gap between space and time. If *The Bronze Age* retains many features

of the *Walking Man*, it took years for *Saint John the Baptist* to lose its superfluous elements to become an original assemblage* in the *Walking Man*, which, like the *Falling Man* or the *Flying Figure*, no longer needed to hide behind a title.*

All these works are more than a representation of movement, they are movement itself. Amplifying movement so as to be in a position to grasp the least sign of life, Rodin searched relentlessly for its essence in his drawings,* which were for Rilke "strange documents

Flying Figure, 1890–91, terracotta, h. 8 ins (21 cm). Musée Rodin, Paris/Meudon.

81

Assemblage:
Female Nude
From The Eternal
Idol *and*
Vegetation,
c. 1895 (?),
plaster,
h. 11 ins (28 cm).
Musée Rodin,
Paris/Meudon.

of the instant;" drawings that made visible a "host of movements hitherto unseen, ever neglected."

In sum, it may be said that Rodin lived by the first line of Baudelaire's poem *Beauty:* "I am beautiful, O mortals! like a dream in stone," while ignoring the second verse: " I hate the way lines are displaced from innate bonds." MPD

■ NATURE: THE BEGINNING AND END OF LIFE

"Nature excites me like a lover, supports me like a mother. She shows that beauty is in everything and is everywhere. She is equally beautiful at dawn, at midday, in the evening; for she is harmony, balance; in a word, she is life." For Rodin, nature was to be written with a capital N. Nature in the widest sense was his only reference: he remained sincere and faithful to this idea to the very end of his life.

Indeed, nature was rich in lessons for the artist. Early in the morning, out in the garden, Rodin would study the structure

of the plants in the flowerbeds. He jotted comments in his notebooks about the straightness of a cedar branch that echoed the outstretched arm of his *Victor Hugo,* cast a handful of horse chestnuts whose shape he found interesting, stuck shells to a plinth like a work of art, found an echo of Greek art in the shape of chicory, experimented with perpendicularity in a sage plant, and described the veins of a cabbage leaf in terms of their architecture.* He studied nature constantly. "I am certain that I would not make a great botanist. Still, I understand botany, in my own way." Because nature inspired the architecture of the cathedrals

Flower, 1914 (?), pencil, brush and sepia on a page from a sketchbook, 5 x 7 ins (14.7 x 18.4 cm). Musée Rodin, Paris.

Rodin admired so much, and because it had exceptional structures to show to those who cared to look, he decided to make it the heart of his work. He used a real garland of ivy dipped in plaster* as an ornament* for his *Whistler's Muse,* and used branches as key pieces in some assemblages.* What better homage could there be to nature, which for Rodin already attained perfection, than abandoning the attempt to reproduce its innate genius? MPD

"Where did I learn to understand sculpture?
In the woods, by looking at the trees; on the road, by looking at the way
the clouds were formed; in the studio, by studying live models;
everywhere, except in schools!"

Rodin in his *Cathedrals of France.*

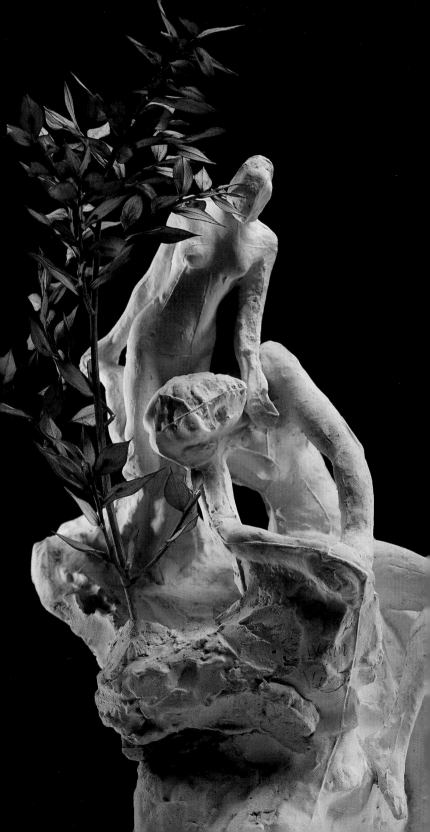

NUDES

Like Michelangelo, Rodin was passionate about the human form, as evinced in works such as *The Bronze Age, Saint John the Baptist*, or *Adam and Eve*. In these sculptures, he examined the human form in its entirety, then bit by bit, removing the limbs, retaining only the essence. With a live model to base his work on, he copied directly from nature*, his entire creative spirit subjugated to the lessons it had to teach him.

In the case of sculptures depicting his contemporaries, Rodin turned to the nude as a means of escaping the inevitable historical reference indicated by the clothing of the period, and above all as a way to give the sculptures a heroic, universal stature. In so doing, he was subscribing to a nineteenth-century theory of the most appropriate way to represent great men. However, Rodin distanced himself from this by depicting realistic nudes, true to life, far from the idealized style preached by the classical, academic tradition. While his *Claude Lorrain* and *Bastien Lepage* are both clothed, the *Monument to Victor Hugo*, commissioned in 1889 and destined to be placed in the Pantheon, was a more delicate matter. Rodin chose to present the great writer as a nude seated on the rocks of Guernesey, where Hugo had spent some years in exile. He refused to give an idealized vision of the body, instead producing a realistic portrait of an elderly man. The project was rejected as unfit for the Pantheon; a marble* version was finally placed in the gardens of the Palais-Royal before being moved to the Musée Rodin.

The nude was an integral part of Rodin's work, a vital stage of his creative process. Whether or not the sculpture was later to be depicted clothed, it was always initially planned nude, since, as Judith Cladel noted, "Although the risk is of creating nothing but an empty skin, the nude, however rough it may be, must be felt to be present under the folds of the cloth, present and palpitating with the emotions of the great, sick heart beneath." The figures of the *Burghers of Calais*, and, later, *Balzac*, are the best examples of this. The figures are naked, solidly built, life-sized and modeled from life; only afterwards were they clothed. After several attempts to get to grips with Balzac's personality, Rodin produced a muscled nude. He had several copies cast, and draped a cloth round each one before selecting the final version. The final, monumental figure is simple in the extreme, culminating in a face with piercing eyes, expressing all the creative genius of the author of the *Human Comedy*. HM

Pierre de Wissant Nude in the Studio, c. 1886.
Photograph C. Bodmer. Musée Rodin, Paris.

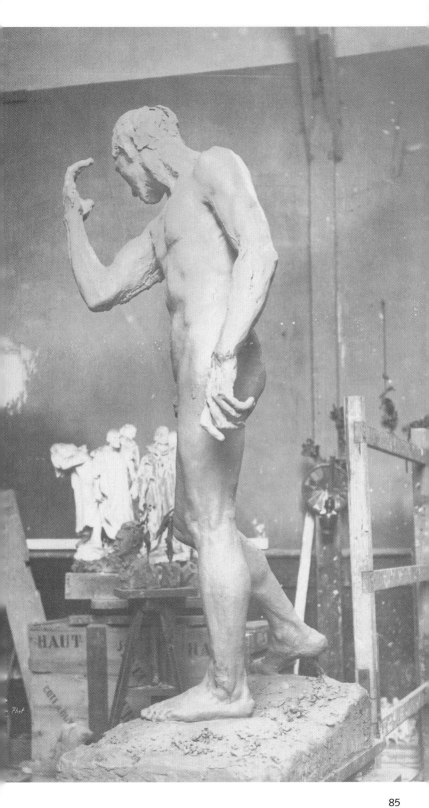

Orientation

Envisioning a sculpture in relation to the space where it is to be presented is a question of restricting the point of view and channeling the viewer's vision. Rodin took this doctrine to extremes in 1903 when he denounced the failure of his contemporaries to recognize the "most elementary principles" of this art: "They no longer sculpt, they no longer model; they simply produce a flat surface. Their works no longer have different facets to be observed."

Rodin knew what he was talking about. He explored to the limits the notion of three dimensions and broke down the concept of orientation by removing the traditional indicators of directionality. The same is true of his drawings,* where the figures appear to float in a void even before the application of decoupage,* or where topsy-turvy portraits,* reminiscent of the kings, queens, and jacks in a deck of cards, seem to incite the viewer to turn the page upside-down.

Rodin's work teaches us to read profile,* by offering and deciphering the form independent of the subject. For the drawings, his writing* serves as guide. The annotations indicate the orientation and sometimes the title;* they suggest a meaning and then dismantle it, as in his collages.* His sculptures face up to the apparent paradox of three-dimensionality through Rodin's insistence on his right to the final choice of a work's orientation. Whether reversal, rotation, assemblage,* repetition*—it was all a delicate question of rhythm and balance.

"When a sculpture is thoroughly modeled inside and out, it composes itself," argued Rodin, thus

the *Prodigal Son* laid horizontally became *Fugit Amor*, which, tipped up vertically, became a dramatic *Fall of Icarus*. For Rodin, the space around the statue was as much a part of the work as the material of the sculpture itself. MPD

Ornamentation

Rodin was deeply influenced by the training he received early in life at La Petite École and with the ornamentalists—designers of decorative details—with whom he began his career. When he was working with Carrier-Belleuse, and in particular during his time in Belgium,* each portrait* or allegorical bust he produced gave ample proof of his technical virtuosity and ability to create abundant decoration.

Rodin was an expert in the art of modeling,* but he entrusted

Double Portrait of a Cambodian Man, Head to Foot, July 1906, pencil, watercolor and gouache on paper, 15 x 8 ins (39.9 x 20.2 cm). Musée Rodin, Paris.

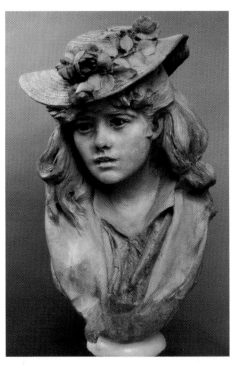

Young Lady in a Flower-Strewn Hat, c. 1865, terracotta, h. 27 ins (69 cm). Musée Rodin, Paris.

Later in life, Rodin was still fascinated by ornamentation in sculpture, devoting an entire chapter to the subject in his *Cathedrals of France*. On occasion, he called on ornamentation specialists to work on features of his sculptures. It is striking to find such decorative elements in the works of his mature years, like the rose on the corsage of *Madame Roll*. Other examples are the luxuriant vegetation that covers a large part of the block of marble* used for *The Death of Adonis*, the detailed depiction of flowers climbing up the leg of a nymph in *Nymphs at Play*, the highly ornate *Triton and Nereid*, or the delicate fruit and blossom on the apple tree in *Eve and the Serpent*. CBU

■ Pain

The concept of pain underlies much of Rodin's oeuvre, reflecting the artist's endeavor to give form to the dream that possessed him.

In the classical tradition, pain was a virtue, something to be borne. When sculpted, the sufferer became exemplary, heroic, and the expression was measured, so as to avoid an over-demonstrative exposition of the emotions. With Rodin's works, pain becomes a human emotion once more. It is a cry of anguish that touches the innermost core of the spectator. Rodin's first major commission, *The Gates of Hell*, proved an opportunity to explore the passion and suffering of man since the Fall, and his desperate and vain attempts to reach out to others.

The committee in charge of putting up the *Monument to the Burghers of Calais* criticized Rodin's depiction of pain in 1885: "We do not understand why the three principal and most prominent subjects represent

specialists with the task of making the leaves, bunches of grapes, and rose petals that feature heavily in his first commissions, *Young Girl in a Rose-Strewn Hat*, *Lilacs*, and *Grapes*, which were all designed for commercial purposes, and first modeled in clay, for a possible cast in bronze* or marble* later. There exist a number of variations on these rather banal figures of young girls, often cast in the same mold and altered by hand before going into the kiln. The *Woman from Lorraine*, also known as *Modesty*, is perhaps the most touching—certainly the most detailed—of these earlier pieces, with her traditional headgear, lace, tresses, and the cross around her neck. Rodin's notebooks dating from this time are filled with detailed ornamental sketches and decorative designs as used by goldsmiths.

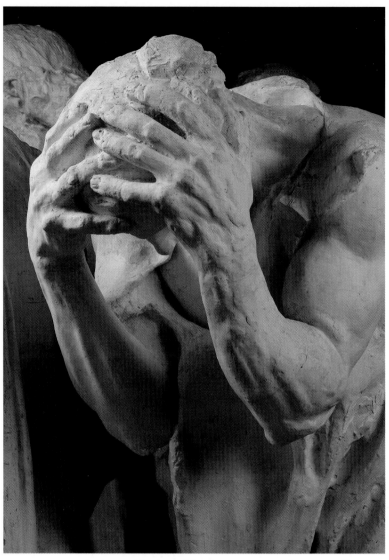

the image of pain.... Monsieur Rodin seems to have gone beyond the bounds of decency in the desperate attitude of the figure on the right, and also in the pose of the burgher on the left, who cannot hold back his tears as he presents the keys to the town." Naturally, Rodin did not agree with their judgment; he designed the monument as a "rosary of suffering" and suggested that the sculpture be positioned very low, so that "the public can all the better gain access to the aspect of poverty and sacrifice, the tragedy."

The *Cry* and the *Head of Pain*—which is in fact the head of a child also seen in *Ugolino* and the *Prodigal Son*—show, concentrated on the face, all the suffering that results from living in this imperfect world. There is a tension between the figures—desperation in the case of Ugolino's son, hope of return in the case of the *Prodigal Son*; for we should never forget that in pain is the possibility of rebirth. HM

Painting

Rodin's only paintings date from his youth.* He first tried his hand at the style of portrait* painting popular in bourgeois circles at the time; works from this period include portraits of his father, Jean-Baptiste, one of his friends, Abel Poulain, and of Rose Beuret, called *Madame Rodin.* In Belgium,* he copied paintings by Rubens, but more important was his discovery of landscape painting, inspired by the Forest of Soignes and the lakes and villages near Brussels. About forty of these paintings survive; they are in oil on cardboard, and represent an attempt to depict as honestly as possible this rainy landscape, in the manner of the Barbizon circle. Some of the paintings made free use of the palette knife, which shows a certain amount of daring for a young artist.

Rodin always admired painters and painting, though he did not feel himself capable of pushing his personal expression as far in painting as he did in sculpture and drawing.* Later, he recalled that during his time in Belgium: "I did a little painting. The light was adorable in that country. The play of sun and rain is so delicate, so varied, and so fleeting that I tried again and again, in vain, to set them down on my canvas. I would have liked to have kept them as a lesson.... But it often rains in Belgium. Madame Rodin carried an umbrella. My box of colors was enough for me."

On his return to France in 1877, Rodin gave up painting to devote himself to drawing. If he had not tried his hand at painting in his youth, it is doubtful whether he would ever have invented his mixed techniques involving ink, gouache, and watercolor. He would probably never have obtained the effects of thickened, intense color that we see in his most striking drawings—the black* series—if he had not experimented with painting in his youth. CBU

Monument to the Burghers of Calais: Andrieu d'Andres (detail), 1889, plaster, h. 7 ft 7 ins (2.32 m). Musée Rodin, Paris/Meudon.

The Brabant Plain, South of the Forest of Soignes, oil on cardboard, 11 x 14 ins (28 x 37 cm). Musée Rodin, Paris.

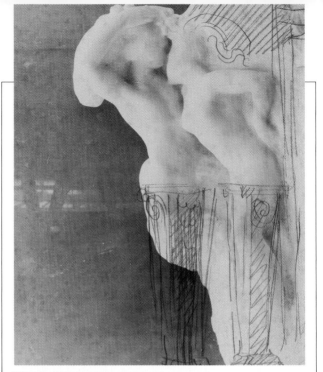

Young Girl Embraced by a Ghost. Photograph E. Druet, touched up by Rodin. Musée Rodin, Paris.

■ PHOTOGRAPHY
A new invention, a new vision

Rodin was very fond of acting the artist in front of the lens. He had his own sculptures photographed from the 1880s onwards, when the journalists and critics were demanding that he respond to public curiosity about *The Gates of Hell*. This was the beginning of a long and fruitful period of collaboration with photographers such as Pannelier and Freuler, who were charged with immortalizing his work for reproduction in art magazines and journals. These photographs became instantly recognizable thanks to the ring of gouache or ink that Rodin would draw round the sculpture to make it stand out from the background. He also called on the services of highly talented photographers like Eugène Druet, whose shots were on display alongside the works at the Rodin retrospective in the pavilion on Place de l'Alma in 1900. The young Eduard Steichen took a supernatural-looking photograph of the majestic *Balzac* at night in the garden of the Villa des Brillants. In many cases, it is unclear what part the sculptor and the photographer respectively played in deciding how to present the work. Rodin left his mark on many photographs of his sculptures, in the form of penciled additions and annotations, which often playfully changed the meaning of the original piece. It was not rare for him to transform a photograph of a drawing* into a new work of art by picking out details in ink or pencil, using them as the backdrop for later drawings, or as an intermediate stage in a work in progress.

For Rodin, photography was a valuable addition to his tools as a sculptor: as the basis for a work of art, photography was free of predetermination and its modernity meant it could be used any way he could imagine. CBU

Plaster

Throughout the nineteenth century, works in plaster were not valued for themselves. They were considered nothing more than a preliminary sketch, a stage in the process of creation that would lead to the definitive final version in more solid materials* such as bronze* or marble*—the latter alone were worthy of attention. A plaster cast was by definition not unique, and a damaged version could easily be destroyed and replaced. Seen as inferior to marble, plaster was nonetheless valued by many artists and students, since it allowed them to make collections* of casts from precious works of ancient art that they would never have been able to own or study otherwise.

Rodin put plaster to good use. Since it was malleable, it opened up a whole spectrum of possibilities. He would take a cast plaster model, and transform it by adding material, creating a new variation* on the original work each time. This is the reason why many of his works exist as variations on a theme, allowing us today to determine the chronology of the pieces. He would try out many possibilities before settling on what was to be the definitive version, as shown by the thirty-odd preparatory studies for works such as the bust of Clémenceau and the studies carried out later for the bust of Clémentel. Many of Rodin's assemblages* and smaller pieces were never exhibited, never produced in bronze or marble, and

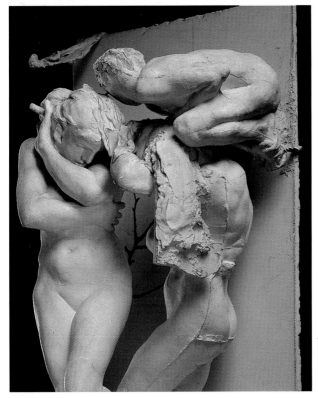

Two Figures of Eve and Crouching Woman (detail), plaster, h. 3 ft 2 ins (96.5 cm). Musée Rodin, Paris/Meudon.

only exist in the fragile medium of plaster, paradoxically designed to be tempory. These works often represent the artist's most intimate and spontaneous bursts of creativity. Today, views have changed from the nineteenth century, and plaster works are considered *objets d'art* in their own right. The material has undeniable advantages: it is a closer reflection of the artist's original gestures, it reflects the various stages in the process of creation, and its matte white* surface, which seems to absorb light, is endlessly fascinating. HM

▨ Plinths

The presentation of his works and their impact on the viewer was a constant concern for Rodin. He turned his back on the classical tradition, in which the statue was placed on a heroic pedestal which raised it above the crowd, both literally and figuratively. Instead, he chose to make the presentation of his works an example of humanity. The plinth, or sometimes the absence of a plinth, was designed to bring the visitor closer to the work of art.

The plinth is also sometimes an integral part of the work, echoing its motifs, as in the *Monument to Claude Lorrain* or *Monument to Sarmiento.* The plinth brings a broader symbolic dimension to the subject of the piece: in the case of Lorrain, a celebrated painter, the horses of Apollo represented the victory of light, and in the case of Sarmiento, president of Argentina, the image of Apollo vanquishing the serpent Python represented his own defeat of the forces of evil and ignorance. The plinth is thus an extension of the work. The *Monument to Victor Hugo*, displayed in the gardens of the Palais Royal in Paris (today in the Musée Rodin), was presented on a plinth made of irregularly shaped blocks of stone, reminiscent of the rocks of Guernesey, where the writer spent time in exile. The *Female Sphinx on a Column* was cast in one piece, with the plinth included as an integral part of the sculpture. Here, Rodin began an exploration that was later taken to the limit in the works of Brancusi.

The plinth also links the work and the viewer. When Rodin chose to place his *Monument to the Burghers of Calais* on a scaffold, the idea was for the visitor to contemplate the work silhouetted against the sky. When he

Monument to Victor Hugo, after 1909, 8 x 10 ins (21.5 x 27.5 cm). Photograph A. Braun. Musée Rodin, Paris.

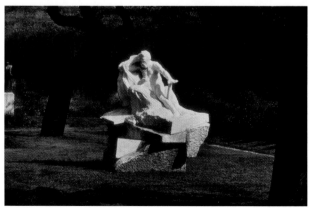

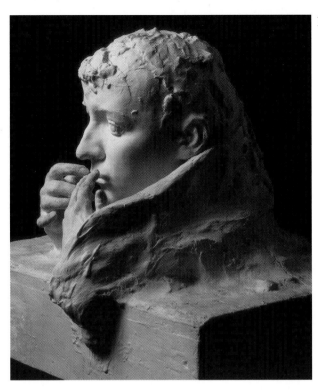

spoke of reducing the plinth to the absolute minimum, making it so low the visitor hardly noticed it, his wish was to bring the work face to face with its audience, and to let it "reach the heart of the subject, like tombs in churches, where the effigies are almost level with the floor." HM

■ Portraits

Rodin's family and friends sat as models* for his earliest portraits: his father, his companion Rose, his friend and fellow sculptor Dalou. In 1883, he painted a portrait of Victor Hugo, hurriedly and from memory, as the writer refused to sit for him. This work established his reputation as a portraitist. As a result, he was constantly in demand to sculpt some of the most important figures of the age, from artists and writers to industrial magnates and politicians. These portraits are honest: they make no concessions to the fame of the subject, capturing with precision the character of each sitter. Rodin was looking for an inner truth, a "resemblance of the soul," hidden beneath the mask of the features. He once said: "In fact, no artistic work requires as much perspicacity as the bust or the portraitSuch an oeuvre deserves a biography."

After the retrospective of Rodin's work in 1900, the sculptor received more and more commissions. Until then most of his busts had been cast in bronze,* but Rodin now found he preferred marble,* a more precious material which enabled him to play with the notions of finished and unfinished surfaces, and of rough and smooth. Marble also matched the certain aura of mystery that he felt in the women* who sat for him. Rodin found that portraits of a woman were "a different question," as the

The Farewell, 1892, plaster, h. 15 ins (38.3 cm). Musée Rodin, Paris/Meudon.

busts of *Madame Fenaille, Eve Fairfax*, or *Hélène de Nostitz* attest.

Rodin also reused the features of some sitters in other, allegorical, works. For example, he topped the bust of *Camille Claudel* with a helmet, and called the new work *Saint George*. On the lips of *The Farewell*, he placed two extremely different models of hands* as a final gesture of separation. The bust of *Mrs. Russell*, the wife of an Australian painter, was also given a helmet and renamed *Pallas*. HM

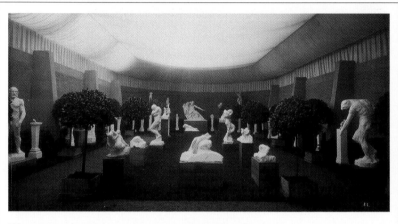

◼ PRESENTATION: RODIN'S MODERNITY

Rodin's works were not always displayed to their best advantage. At the Royal Academy in London in 1884, his *Bronze Age* was placed in front of the entrance to the toilets. For Rodin himself, the worst placing for his sculptures was up against a wall—even more unforgivable than bad lighting. While the general layout of the exhibition naturally depended on the space allotted, Rodin always gave pride of place to what he considered to be the most emblematic pieces. Thus in his pavilion on Place de l'Alma for the 1900 exhibition, he chose to go against expectations by placing his *Balzac*—the source of such scandal*—in the central alley, where visitors entering the exhibition could not fail to see it.

Decoration was another important part of the presentation. Rodin was particularly fond of pale, neutral, discreet colors. The plinths* were often draped in colored fabric. The sculptor also played with the contrasts between bronze,* marble,* and plaster* works. The sculptures might also be interspersed with trees and flowers, as in a Renaissance garden. For Rodin, the way his works were presented was an integral part of his oeuvre. Very early in his career, with his exhibitions* in Belgium and Holland, Rodin became aware of the important role played by the presence or absence, the harmony or disproportion of the plinth. In Brussels, for example, his *Eve* was placed directly on the floor. At the exhibition in 1900, the small plaster pieces were shown on tall columns—some measuring more than two meters—like "white birds on perches." Some of the sculptures on their original plinth were then placed on a second pedestal, making them very tall indeed.

Rodin saw exhibitions as a chance to experiment with presentation just as he did in his own studio,* where he enjoyed total freedom in the arrangement of his works. In 1899, the *Death of Elects* was presented in a wooden box resembling a sarcophagus (later removed). In 1903, in Vienna, the *Hand of God* was presented perpendicular to the wall. CBU

Profiles

Although it might be explained by his training, it is surprising to realize that Rodin's understanding of the work in three dimensions was based on drawing.* As he himself put it, "I do what one might term 'drawing in depth.'" As he worked, his eye was constantly roving back and forth from the model* to the clay, carrying out an incessant and multidirectional comparison of the twin outlines, adjusting here, tightening the line a touch there, recreating the profile little by little in the clay. For Rodin, the profile was vital in constructing the force of the sculpture.

He was prompted by an absolutely precise observation of nature,* and to get closer to its truth, dared to amplify lines and follow the general scope of the movement* in order to produce a more faithful image of the living model. In his work, the surfaces that link the profiles together tend to become wider in parallel, inclining towards a simplification of the mass of the body that diminishes the contrast of shades and melds tones of grey.* This differentiation between the form and the mass of the block becomes a line in itself, guiding the development of the sculpture little by little towards decontextualization and abstraction.

His use of profiles gives rise to fresh interpretations; the form becomes synthesized and loses its original meaning. "When I have the body of a beautiful woman as a model, the drawings I make bring me images of insects, birds, fish." This in turn makes a new orientation* of the work possible. What is more, in the relationship of the substance of the sculpture with the void, it becomes conceivable to create assemblages* from figures produced individually.

What can we say about the drawings where a uniformly dark wash drowns the human form beneath the trace* of a single, sober gesture? The female form becomes nothing more than a cross, a punctuation mark. By working on the profile alone, Rodin dares produce what in semiotic terms is a pure sign. MPD

Exhibition in the Manès Pavilion in Prague, 1902. Photograph R. Bruner-Dvorak. Musée Rodin, Paris.

Clenched Hand. Photograph E. Druet. Musée Rodin, Paris.

Christ and Mary Magdalen,
c. 1894, plaster,
h. 33 ins (84.5 cm).
Musée Rodin, Paris.

■ RELIGION
An unshakeable faith in nature

When his sister Maria died in 1862, Rodin, overcome with grief, spent some months in the monastery of the Order of the Holy Sacrament on rue Saint-Jacques in Paris. During his time there, he was granted permission to draw and model clay. It was here that he sculpted the bust of Father Eymard, the founder of the Order. A few months after the sculpture was completed, Father Eymard had little difficulty in convincing the young Rodin that he was ill-suited to the contemplative life.

Rodin always claimed that if religion had not existed, he would have had to invent it, since he saw the act of creation as an act of religious adoration, and compared the artist to God. "Does the sculptor not adore when he notices the grandiose forms of the objects he studies, when, from the midst of fleeting lines, he knows to bring out the eternal core of every being, when he seems to discern in the very heart of the divinity the unchanging models from which all creatures are molded?" His *Hand of God*, which breathes life into Adam and Eve, is also the hand of the sculptor, which "makes the creative force resound in all living flesh."

The links between suffering and creation in Rodin's work are always close to the theme of religion. In *Christ and Mary Magdalen*, the female figure is in fact a repetition* of his *Meditation*, as if Rodin wanted to associate the death* of the son of God not just with a figure of key importance in the Gospels, the forgiven sinner, but also with human angst.

A much later work, *The Cathedral* (1908), is composed of two hands* forming a gesture of prayer. It gives a much more serene image of spiritual life which was gradually gaining in importance for Rodin, one where the whole of nature* was a part of the mystery of creation. At every stage in his life, creation, whether viewed in religious or artistic terms, was Rodin's major preoccupation. CBU

"He pointed to Nature ever more insistently, advising me to return to God's own work, immortal but no longer recognized."

Rainer Maria Rilke in his *Auguste Rodin.*

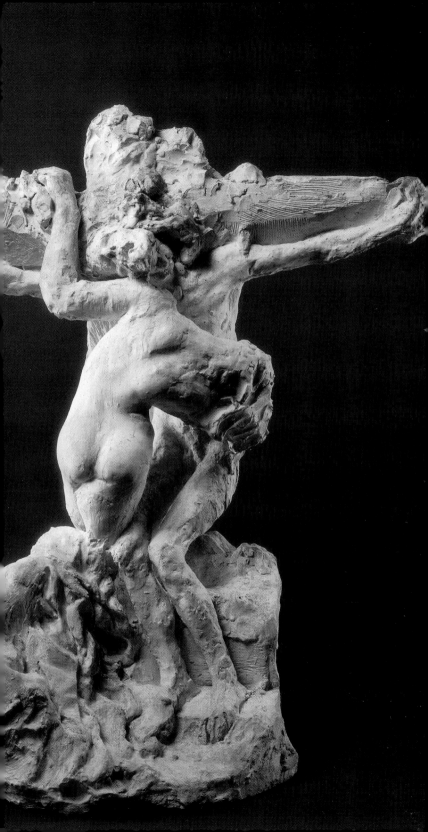

■ REPETITION

T owards the end of the 1880s, Rodin began to use casts of his earlier sculptures as elements for assemblage* in new groups. Casting can produce an almost infinite number of identical versions of a given form, and the procedure gave Rodin the opportunity to explore the idea of repetition.

Through this process he was able to show the same sculpture seen from different angles; this is the principle behind the group *Three Shades* (the same figure presented facing, three-quarter facing, and in profile*), later included in the *Gates of Hell*, which is itself designed to be viewed head-on. Other pieces such as *Three Faunesses* took Rodin towards more symmetrical assemblages in which the motif is constructed around a central axis. Such pieces form a closed system, giving an impression of infinitely repeated movement.* The assemblages* entitled *Dance Movement B* and *Two Night Figures* represent another experiment in repetition, in which the artist juxtaposes the same figures facing each other, with the same orientation,* breaking down movement into its constituent moments.

Some of Rodin's sculptures are constructed around the notion of the mirror image, which play with twin versions of the same piece. He developed this idea in *Dried-up Springs* of 1889. This piece is composed of two casts of the *Belle Heaulmière*, almost face to face, framed by a grotto. Rodin's exploration of the concept of repetition is not limited to sculpture. In some drawings,* for example the *Two Portraits of Comtesse Nourys Rohozinska Head to Foot* or the double portrait* *Cambodians* (1906), he creates an illusion of exact copies obtained by print, as if one head were an exact, symmetrical transfer of the other, which is not quite the case. In 1904, Marcel Duchamp, who was to push the limits of the same technique, produced a double etched print entitled *The Artist's Grandmother*, which is very close to the double portraits produced by Rodin.

The idea of repeating a figure to amplify its rhythm and force of expression might have come to Rodin through his training in ornamentation* in his youth,* since, by their very nature, decorative elements are designed to be repeated. "Repetition and regularity are the basis of things of beauty. It is a law," Rodin wrote. As the art critic Léo Steinberg has pointed out, the concept of repetition allows the artist to discover new and complex rhythms, "a temporal prolonging of the initial state" where "the seeming naturalism of the piece disintegrates." CBU

Three Faunesses, before 1896, plaster, h. 9 ins (24,8 cm).
Musée Rodin, Paris/Meudon.

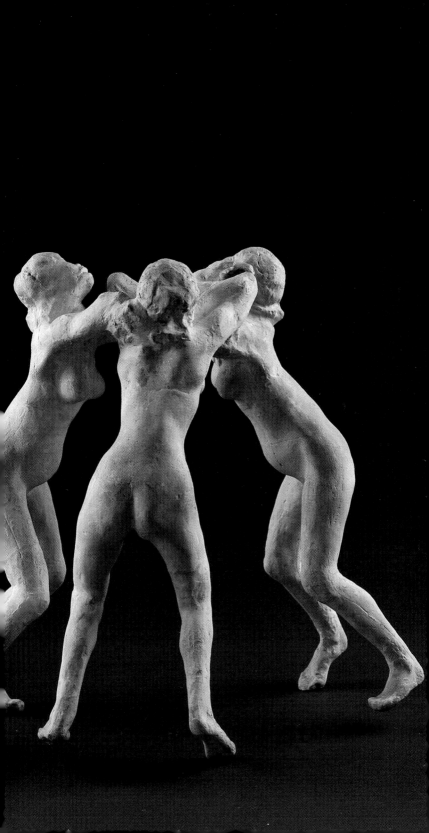

Rodin Standing by his Monumental Thinker, 1906. Photograph A. Harlingue. Musée Rodin, Paris.

▮ Scale

For Rodin, the figures of his sculptures were never finished, never frozen in time. Each figure contained within itself a multitude of possibilities: by changing the scale of a piece, reducing or increasing the dimensions, he could change the perception and meaning of his work. He reduced the scale of *The Kiss* and *Eternal Spring,* for example, and then gave the rights to one of his casters, M. Barbedienne. Graceful, pleasant pieces, these *objets d'art* perfectly fulfilled the requirements of ever greater numbers of amateur collectors.

The process of increasing the dimensions of a sculpture was more interesting in that it permitted Rodin to add a "supplement of soul" to his creations. Rodin began to investigate this procedure's possibilities after 1900 with the help of his assistant Henri Lebossé. Individual works were increased in scale piece by piece, and the final assemblage* of the individual elements was often a tricky task. The proportions of each piece might have altered slightly, and it was Lebossé's job to ensure that the finished statue reflected the original proportions of Rodin's sculpture.

This method of increasing the scale of a piece was above all a way for Rodin to increase the corresponding impact of a work, to make a new space his own, and to work with the notion of dominance through sheer size. A number of his works bear the seeds of monumentality within their original format, and the process of increasing the scale brought their sheer imposing power to fruition. His *Walking Man,* for instance, only attained its forceful impact after being

increased in scale in 1905–06. It was at this time that the piece was given the title* we know it by today, probably by one of the casters working on the change of scale.

But the most famous example of Rodin's experiments with scale is still *The Thinker*. First created in 1880–81 in a medium-sized format for *The Gates of Hell*, this piece was originally designed to represent Dante watching over the inferno. However, it was the monumental version, created in 1902–03, that made the statue into the emblematic, world-famous sculpture that is so familiar to art lovers today. HM

■ Scandal

Having three times failed the entrance examination to the prestigious École des Beaux-Arts in Paris, Rodin craved artistic recognition all his life. He accepted commissions enthusiastically and he found it unfortunate that his modernity should be considered shocking. The scandals that marked his career are indicative of a deep cultural division between the sculptor, the people placing the commission, and the general public, who were often incapable of understanding the results of daring artistic exploration.

Rodin's first major work, *The Bronze Age*—a "life-sized nude" as Rilke termed it—provoked a scandal when it was first exhibited in Brussels, then Paris in 1877. The sculpture seemed so full of life that shocked critics accused Rodin of having cast the statue from his model,* a young Belgian soldier. Only after other artists spoke up for Rodin did controversy die down. At least his name was finally on everyone's lips, and

LE NOUVEAU DÉPUTÉ
« Voyons, je n'ai rien oublié : j'ai pioché mon dictionnaire d'argot, j'ai travaillé la boxe... Je peux siéger. »

LE BALZAC DE RODIN
« Je le trouve un peu trop p'homme de terre en robe de chambre.
— Moi, j'admire en bloc ! »

AH ! MAIS ! AH ! MAI !
Allégorie du printemps à la mode de cette année.

Caricature of *Balzac* by Luc. *La Revue de la Marne*, June 12, 1898. Musée Rodin, Paris.

shortly afterwards he received his first major official commission for *The Gates of Hell*.

His *Monument to Balzac*, first exhibited at the Paris Salon of 1898, created another enormous scandal. The Société des Gens de Lettres [Association of Men of Letters] commissioned the monumental piece in 1891, but later rejected it on the grounds that it did not adequately reflect the personality of the great author. The work—which Rodin was to consider his greatest artistic legacy—was derided in numerous caricatures of the day.

In 1906, a selection of Rodin's drawings* of female nudes provoked outrage in Germany. The artist was accused of being a "pornographer" and his drawings were called "disgusting, nauseating." Faced with such a barrage of criticism, the organizer of the exhibition,* Count Kessler, resigned from his post as director of the museum of the Grand Duchy of Weimar. HM

Female Nude in the Water, Seen From Behind, pencil, watercolor, and gouache on paper, 12 x 9 ins (32 x 24.6 cm). Musée Rodin, Paris.

■ Sea

The sea was always a source of inspiration for Rodin's philosophical musings. He jotted in his notebooks "This sort of cobalt blue of the sea ... oh, this blue ... Blue ink has been poured into the sea." These allusions refer most often to his drawings,* which were inspired by memories of the sea more than his sculptures were.

For Rodin, the sea was sensual and feminine. He often depicted the goddess Venus as a monad,* her genitalia on display and watercolor covering her body as if she were sinking into the depths. In other drawings, the marine title* might have been inspired by the form of the drawing (a woman with her hair trailing in the water is entitled *A Reef*, evoking a rock covered in trailing seaweed) or by a great wash of blue-green color that swamps the figures (*On the Sea Bed, Female Swimmer, Rolled by the Sea, Siren, A Drowning*, etc.).

Rodin also considered the sea as a classical problem of form—it offered him the possibility to explore how best to represent movement* in nature. "I see in the sea the essential forms of fauna and flora that pass by incessantly. Elsewhere, these forms seem to be fixed; here, they are in a process of perpetual evolution." His research resulted in works such as *The Wave*, where two superimposed bodies circle each other endlessly, or the *Fish-Woman*, whose head* rises from the waves. This last piece was conceived as part of a fountain where the water would in turn spurt forth from the woman's mouth, symbolizing the symbiosis of the woman and the sea, bound together by the artist by the twin poles of sexuality and creation. CBU

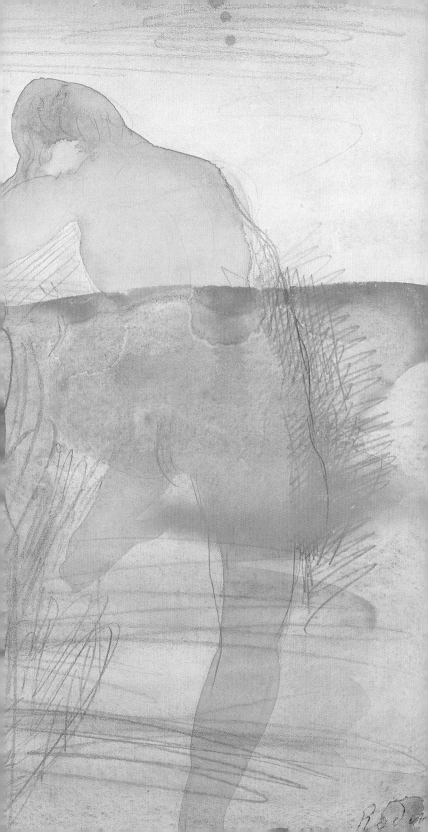

■ STUDIOS

Rodin rented his first studio in the rue Lebrun in Paris. It was a damp, drafty stable, yet it was a step up from the cramped conditions poverty had previously forced him to accept. It was here that he created his first works, among them *Bacchante* and the *Man with a Broken Nose*—broken off by chance* thanks to a particularly sharp frost.

On his return from Belgium* in 1877, Rodin rented premises at 36 rue des Fourneaux in Paris (today rue Falguière), in a series of studios designed especially for artists. Within three years, however, the premises proved too small for him to be able to work properly. As he began work on *The Gates of Hell* the authorities in charge of the state marble sculpture collection, on the rue de l'Université in Paris, granted him a studio there, described as "sincerely austere" by one visitor.

Rodin kept this studio until his death. In 1886 Rodin took over a very sparse room, in what was in those days the suburbs of Paris, at 117 boulevard de Vaugirard (now in Paris). The writer Edmond de Goncourt described the "walls covered in splashes of plaster, the inadequate little cast iron stove.... all the casts of heads, arms, legs, in the midst of which two skinny cats resemble the effigies of fantastic griffins."

In 1890, he left this studio for space at 68 boulevard d'Italie (also now in Paris). It was in this romantic eighteenth-century house, partly in ruins, that the writers George Sand and Alfred de Musset had carried on their scandalous affair; it was now home to Rodin's studios as well as his secret trysts with his lover Camille Claudel.

Rodin's last studio was even further from the busy center of Paris than these two retreats in the far reaches of

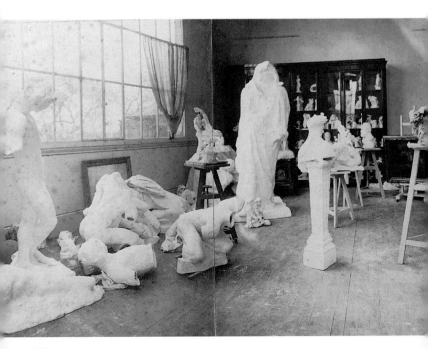

the suburbs. Late in the year 1895, he chose to distance himself from the capital, moving to the town of Meudon, south west of Paris. He purchased the Villa des Brillants and lived there with his companion, Rose Beuret. A few years later, he began several building projects on the grounds: in 1901, he reconstructed the pavilion from his exhibition* the year before at Place de l'Alma and moved his works into it and in 1907, he decided to reproduce the façade of the nearby château d'Issy. The other pre-existing buildings were sufficiently large to permit Rodin's secretaries, assistant sculptors, and casters to live on the premises, some fifty people in all. Thus, the villa in Meudon, initially chosen for its peace and quiet far from the buzz of the capital, became in its turn a hive of activity. Gradually, more and more people came to visit, since the villa was a melting pot of artistic creativity, fusing Rodin's private sphere with his intense work* practices. In 1908 Rodin returned to Paris, settling in the Hôtel Biron*; for the rest of his life he divided his time between the two homes. Today, in accordance with his wishes, the two homes are both part of the museum dedicated to the artist's life and work. MPD

Panoramic View of the Meudon Studio, c. 1900. Photograph E. Druet. Musée Rodin, Paris.

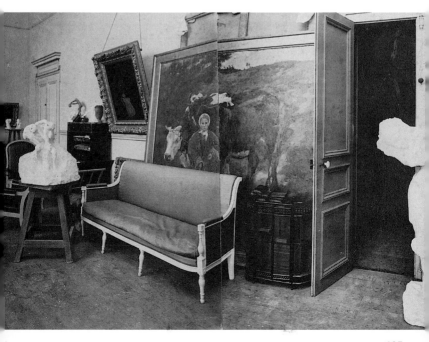

Time

"It is vital not to hurry," Rodin once confided to Rainer Maria Rilke. For him, attention to detail and the regularity of his work* reduced the role of inspiration; time and patience were the principal requirements for his creations. His work always progressed rather slowly—a problem for many of the people who charged him with commissions. However, he felt it was imperative to take his time and "carry [the work] to term, then give birth: everything is there," as Rilke put it. Pressure and haste had a negative effect on Rodin's creativity, since, as he said, "to produce something good, you must have the time to forget." However, this did not diminish the enthusiasm he brought to each new project or his "joy in work well done."

René Chéruy, Rodin's private secretary from 1902 to 1908, recounted how the sculptor was slow "in making decisions about his monuments; he leaves them to one side for months or years if he is not being pressed for them (…) or he requests extensions to the deadline when he is pressed for the work, like for the *Burghers* or *Balzac*." Chéruy added that Rodin "liked to keep his works with him for a long time, even if they seem to be almost finished."

Thus it took Rodin seven years to sculpt the *Monument to Claude Lorrain*, five for the *Monument to the Burghers of Calais*, plus a further three years to set the sculpture up in the chosen site and for the official inauguration. The *Monument to Balzac*, commissioned in 1891 by the Société des Gens de Lettres [Association of Men of Letters], was supposed to have been delivered eighteen months later, but was only finished in 1898. This extra time, although unforeseen, was a vital part of the creative process. Rodin was in thrall to his need to take his time and had no choice but to submit to the demands of his creative spirit. The work on each project and each sculpture gave rise to new works, opening up unexplored artistic perspectives which he was unable to resist. While working the bust of *Clémenceau*, for example, he produced some thirty separate studies based on the original plaster* model, each of which he revised until a definitive version was finally selected. Rodin also returned constantly to his *Balzac*, producing studies of the figure standing, legs apart, both nude* and then clothed. He also produced a number of powerful studies of the face, with abundant locks of hair and a piercing gaze, before settling on the final form for the monumentally sculpted head.* As Rodin said, "I love reflecting on a piece, even when the work is nearly finished." HM

■ Titles

In describing the superb variety of forms given to Rodin's one constant object of study, the human body, Camille Mauclair was right to say that Rodin's "marbles, his plasters, could be given numbers as titles, like sonatas." There is indeed a great sense of emotion in these variations* on the single, universal theme, one that for Rodin was a vital means of expression: "There is no subject, only sculpture."

Rodin himself indicated that the question of the title was of secondary importance. "Above all, one must take nature as she comes, and once the work is entirely finished, if one wishes, one can then attribute a precise meaning to it." Even though a title is necessary to make the piece accessible to the general public, Rodin was uninterested in them; for him they were an intellectual approach to the sculpture once the intuitive work of creation is over, a question of reception. At a time when symbolism was at its height in literature, Rodin left the issue of a work's title to friends, art critics, or writers. The titles of his work vary; they can be descriptive or symbolic. They sometimes refer to books,* mythology, nature's* infinity, or clichés from the world of art, which "awaken the imagination of the spectator without any outside help.... However, far from ringing the imagination within narrow limits, they give it the vigor to wander freely. And for me, that is the role of art." This point of view is not contradicted by works such as the *Dried-up Springs* or the *Secret*. Before presenting his work to the public, Rodin did sometimes overcome his resistance to titles and give his pieces names once they were finished,

Birth of Venus Rising From the Waves. Anonymous photograph, touched up and annotated by Rodin, before 1889, 4 x 7 ins (10 x 18.4 cm). Musée Rodin, Paris.

"The first lapse in taste is to believe that the subject is something."

Rodin, *Notebook* 28.

tempted by the play of lines that stirred echoes in his mind. In such cases, he noted the orientation* and meaning in his own writing,* sometimes directly on the sculpture itself. In these rare cases, the choice of the title thus becomes the last stage of the sculptor's creative act. The second he puts down his pencil, he steps out of his role as creator of the piece, and becomes a spectator. MPD

Traces

Traces—in the form of lines or marks left by the tools or the mold—are a distinctive feature of Rodin's work, inscribing in the final version the signs of the work* carried out in previous stages. These physical traces in the material are a precious element of Rodin's aesthetic; they evoke the path taken by the sculpture.

The body of the *Meditation (without Arms),* for example, is striated with long seams from the cast, that are retained in the bronze.* The lines along the body of the small *Reclining Woman* highlight her movement.* The *Bust of the Nude Study C of Balzac* reproduces in great detail the play of seams and lines, as well as numerous marks left by the sculptor's tools, in particular the small tooth marks left by the gradine—a type of notched chisel—in the clay. The frame that attached *Eve* by the ankle to the mound on which she stands was cast along with the rest of the statue. Apart from these traces deliberately left on the finished work, others are the fruit of chance* or accident, such as the head* of *Madame Fenaille,* dropped on a tiled floor. The pattern of the tiling was imprinted on the lower part of the cheek and the chin, producing an effect that Rodin decided to keep.

Rodin's marbles also retain the traces of earlier stages. For

Reclining Woman, c. 1895, plaster, h. 5 ins (13 cm). Musée Rodin, Paris/Meudon.

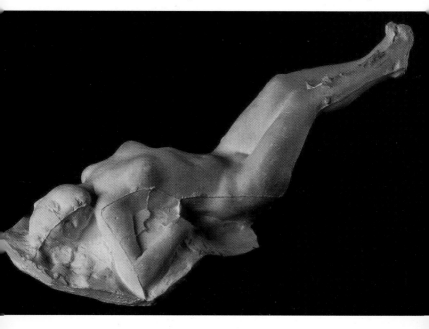

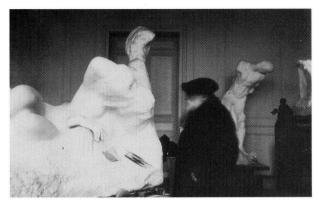

Rodin In Front of the Unfinished Ariane, 1910–11. Anonymous photograph. Musée Rodin, Paris.

example, nails were used to indicate positioning when the piece was to be enlarged. It was normal practice to remove them once the forms were reproduced as required and the marble was finished. Rodin often chose to leave them in place as witness to the process of fabrication, thus breaking with the traditional, classical, and academic illusion of the work created spontaneously and as the result of inspiration. By leaving these traces on the finished work, he reminded the spectator that every sculpture is the product of an artist sweating over his raw materials. On occasion, the traces integrated into the final work add a touch of humor, like the two nails in place of nipples on the *Bust of the Duchesse de Choiseul,* which highlight the sitter's provocative air. HM

Unfinished

"And some imbeciles have criticized me for not finishing my sculpture!. . . Does Nature finish her work? Do we fiddle around with trees?" Rodin's anger as he read the critic's comments spoke volumes. He and his critics spoke two entirely separate languages. For the critics, a finished sculpture had to depict a complete human

figure and they saw Rodin's fragmentation* of the body as sheer provocation. They based their arguments on what Rilke termed a "complicated process of reflection characterized by narrow-minded pedantry, which tells us that a body needs arms, and that a body without arms cannot be considered complete." The critics believed that unfinished necessarily meant incomplete, and saw a challenge to artistic propriety in the way Rodin chose to exhibit works in a state many of them could only conceive of as temporary. Rodin's marbles,* for example, still bore the traces* of his work on them, and he considered his plasters* as something more than an invisible, intermediary step in the development of the work towards the finality of bronze* or marble.

For Rodin, the last stage in the development of a statue was marked not by its presentation to the public nor by the moment the artist signed it. Nothing could halt the process of development which was the essence of the work of art. He took time* to step back from his works before returning to the subject and producing variations* on the same theme. For Rodin, the unfinished look of

some marble pieces, far from the *non finito* of Michelangelo, was charged with symbolism, illustrating the process of development by which a piece broke free from the raw material* or, on the contrary, returned to it in an ambivalent movement* of hybridization.* More than just a means of expression, Rodin saw "unfinished" work as a systematic portrayal of his creative philosophy.

He believed that to "finish" a work of art, meant nothing other than to denature it. "Ignorant people, when they see accurate plans and a well-composed, generous technique, say 'It is not finished'; in fact, it is precisely the opposite, because only in work pushed to the very limit can one obtain the solidity of the whole and this living aspect.... The general public does not understand this, confusing art with tidiness." MPD

▨ Variations

In Rodin's oeuvre, variation is a guiding principle, yet almost in spite of him, since this principle is defined by a global vision of the piece which, by definition, can only exist after the fact. For Rodin, each work lived and had to be experienced only in the moment of observation and in its own space.

While a work like the *Gates of Hell* brings a number of works together in one space, each work can be presented seperately or in an infinity of combinations with other works, since each is entirely independent. The elements of Rodin's oeuvre can be conjugated, in the grammatical sense. As the work is complete in itself, it can be multiplied by molding or copying, subdivided by fragmenta-

tion,* undergo a change of scale,* of material,* or altered by assemblage* or repetition.* This incessant game of variations on a central core of forms seduced the sculptor, who was fascinated by the possibilities of the unfinished work: "When the figures are well-modeled, they approach one another and form new groups automatically." The same process is visible in Rodin's drawings*: his use of decoupage,* cutting round the outlines of figures, re-centering, collage,* and highlighting details. These techniques create a constant to-and-fro between the two transitory zones of the paper and the space beyond it. The end result is a series of works linked by a formal leit-motif, such as the *Eros* that forms an arch* across several watercolors of women, renewing the orientation* of each image. Rodin's oeuvre is a multifarious hybrid*—he invents the words, terms, and syntax of his own unique artistic language,

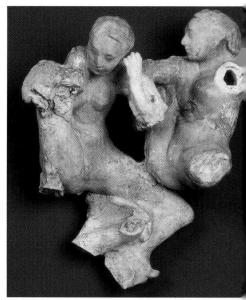

Assemblage: Two Studies for Iris, c. 1908–09 (?), plaster, h. 9 ins (23.8 cm). Musée Rodin, Paris/Meudon.

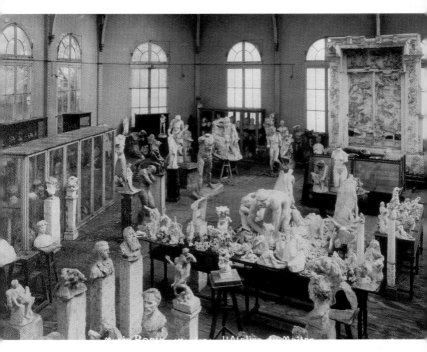

rich in playful conjugations and derivations, close to the extravagant literary creations of some of his contemporaries, such as Raymond Roussel. MPD

■ White

In a 1902 letter, Rilke described the play of light on the plasters* that Rodin stored in Meudon: "Tomorrow morning, at the same time, I shall return, and maybe a few days after that: it's immense. But it's also terribly demanding, first because of the quantity, then because everything is white—you wander among all these dazzling plasters, in the heart of this brightly lit pavilion, as if surrounded by snow. My eyes hurt, and my hands too...."

Contemplating the sculptor's work is physically challenging, taking the viewer to the very heart of the mystery of Rodin's creative genius. While light seems to slide off bronze,* plaster seems to absorb and then diffuse it. The white of the plaster is in itself a paradox, a non-color that remains discreet while bearing a bright charge of light, which caresses every detail, every blemish, of the surface, as if it were skin. The light blends with the white of the sculpture, and at the same time highlights its brilliance. Through variations in the intensity of the light, the plaster seems to possess a number of different lives.

Rodin grasped the innermost significance of this play of light on white plaster, and it is certainly no coincidence that almost all the works he chose to display at his retrospective on Place de l'Alma in 1900 were plasters. He made the same choice for the 1904 Düsseldorf exhibition, setting his sculptures up in an entirely white room—a decision which baffled certain critics: "Rodin.... showed a whole forest of sculptures, but unfortunately all in plaster, dazzling white, without the least nuance of color, all in a white room." On the other hand, when he

Rodin's Studio, photograph Bernes and Marouteau. Musée Rodin, Paris.

visited the Villa des Brillants in 1906, the Argentinean Eduardo Schiaffino marveled at the way the collection of plasters played with light: "We enter a large room, filled with light like a lantern, where the infinite whiteness of a whole crowd of statues, silently gesticulating, seizes us and moves us deeply." HM

Rodin's half-artistic, half-erotic* relationships were dalliances with Gwen John and Sophie Postolska. But the one burning passion in Rodin's chaotic love life was Camille Claudel. She represented the fusion of his twin passions: work* and the human form. Rodin had more platonic relationships with other women he

Rodin Surrounded by Women, May 31, 1902. Photograph R. Bruner-Dvorak. Musée Rodin, Paris.

■ Women

Rodin was fond of saying that women understood him better than men. He certainly had a subtle understanding of women, and was able to translate the sheen of their skin onto paper, the curves of their bodies in clay. Without his highly defined sense of what Rodin chastely termed the beauty of life, he would not have been able to model the female form in clay with as much sensuality. His studio* attracted many female visitors. The wealthier ones came in the hope of persuading Rodin to immortalize them in a bust, wishing to feel the magic of his artist's gaze and hands. The women Rodin sculpted were as fascinated by him as he was by them. Many women passed through his studio, to place commissions, or as models,* society acquaintances, pupils, or mistresses. Among

respected from an artistic or intellectual point of view, such as Hélène de Nostitz, whom he saw as a kindred spirit. Another friend was Judith Cladel. Although he never produced her portrait,* she remained a firm friend to the end of his life, supporting him through many difficult times, and even helping with the creation of the Musée Rodin after his death. Rodin's last love, Claire Coudert, also known as the Duchesse de Choiseul, was the complete opposite. She was sly and unscrupulous, and took advantage of the elderly Rodin's credulity and vanity to defraud him. Finally, there was his faithful, discreet, and patient companion, Rose Beuret, who stood by him for fifty years, despite his constant infidelities, and whom he finally married shortly before her death in 1917. MPD

■ WORK
A lifelong obsession

The poet Rainer Maria Rilke said of Rodin: "Only his work spoke to him. It spoke to him in the morning, when he woke up, and in the evening its sound continued between his hands like in an instrument after it has been put down." The poet admitted that the sculptor had taught him to live through his work, since "I really feel it. I feel that working is living without dying."

Both in Meudon and in his Parisian studios* (particularly at the state marble sculpture collection) Rodin worked unceasingly, returning constantly to the pieces underway, working from a live model,* trying out new and original combinations, adding or removing features. Beneath his fingers, the material* became the source of myriad possibilities for experimentation. He drew and sketched, and then gave substance to the resulting designs. His oeuvre consisted of a concentrated core of forms teased out in an infinity of variations.* However, there was no way he could have produced the sheer number of pieces that came from his studios without the help of a crowd of craftsmen who came to work for him after 1900: assistants to hew the marble statues, casters to produce as many repeat molds of selected pieces as Rodin required for his different studies.

Even once he had acquired a great reputation, Rodin worked as hard, as enthusiastically, and as passionately as he had at the beginning of his career. He contributed a column for a collective project that never saw the light of day, entitled a *Monument to Labor* (1898–99), which was an homage to the virtues of ordinary labor that he extolled to the end of his life. The monument was planned to illustrate all trades, from the most back-breaking physical labor to the most intellectual and artistic. As Rodin himself said, "How much happier humanity would be if instead of being the ransom of existence, labor were its goal!" HM

The Tower of Labor, plaster, h. 4 ft 11 ins (1.51 m). Musée Rodin, Paris.

"Woman is the only thing today that is still a masterpiece."

Rodin, *Notes and Scribbles* [*Notes et brouillons*] VI.

■ WRITING: AN ABSOLUTE NEED FOR SINCERITY

While Rodin was still alive, a number of interviews, as well as articles in praise of ancient art, dance,* nature,* or France's cathedrals,* were published in his name. There was a real curiosity about his thoughts and philosophy. However, of all these works, only one was actually planned as a book.

Published by Albin Michel in 1914, Rodin's *Cathedrals of France* was written with the assistance of his secretary Charles Morose. The experience was a drawn-out and painful one for Rodin, who considered the rewriting of his personal notes a betrayal. These jottings, scattered in notebooks or on the backs of envelopes, sometimes fail to render the artist's wide-ranging thoughts, or his astonishment at the marvels he discovered through his nature study. The number of notes and jottings expanded exponentially from 1900.

When he had the rather chaotic notes organized and transcribed in 1913, it was with the paradoxical wish to distance himself from his own thoughts so as to be able to see them more clearly. On occasion, he let himself be tempted by a play on words inspired by the decade-old jottings or a mistake by his secretaries. His absolute need for sincerity meant that the process of writing took place in several stages: "It is difficult to write a book.... it's like producing a sculpture." The result was a fluid text describing the artist's impressions of France's great cathedrals placed next to drawings* of their architecture,* the two complementing and completing each other.

Rodin used writing for brief annotations rather than for the development of a long cogitative process. For him, words were the crystallization of an idea, a color, a shade; they often left the notebook behind, acting as reminders directly on the edges of the drawing, or even on the plaster* of a statue in progress. Occasionally, the words jotted on the plaster are the finishing touch, giving the work its title.* In Rodin's work, the word is an integral part of the creative process, from the piece's inception to the final result. MPD

Notebook 22. Verso of sheet 31 and recto of sheet 32, 1911–13. Musée Rodin, Paris.

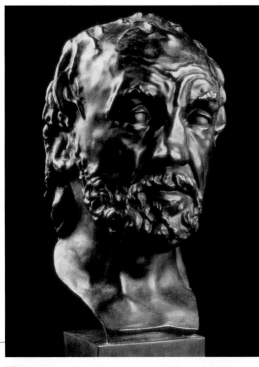

The Man with the Broken Nose, 1864, bronze, h. 12 ins (31.8 cm). Musée Rodin, Paris.

■ YOUTH: THE SLOW APPRENTICESHIP

"You do not understand anything when you're young: it only comes later, slowly." And yet, Rodin's whole life was guided by his desire to comprehend.

At the age of fourteen, he began his studies at La Petite École, despite the initial reservations of his family.* He had the good fortune to be guided by an exceptional teacher, Lecoq de Boisbaudran, who trained him to improve his memory through copying eighteenth-century works, and encouraged him to study what he called "the immense field, hardly explored, of the living action and changing and fleeting effects" of the live model in the open air. "Most of what he taught me still remains with me," Rodin said years later.

The following year, he took lessons in modeling,* dividing his time between La Petite École, the Louvre, and the Imperial Library. He discovered the art of ancient Greece and Rome, and the magic of Italy* in albums after the manner of Michelangelo, and took evening classes in drawing from life. Despite all his hard work,* he failed the entrance examination to the École des Beaux-Arts three times. After this failure, nothing could diminish his tenacity and sincerity when it came to his work. The need to earn a living led him to work for decorators and ornamentalists (designers of decorative details). "At that time, I used to go into my garden, I studied the stems, the seams of the leaves, and all this came in useful: I inserted a little bit of nature into the historical ornamentation." After the death of his sister Maria in 1862, Rodin entered the Order of the Holy Sacrament, an experience which paradoxically showed him his true path. After sculpting the bust of Father Eymard, founder of the monastery, he realized that his way lay in sculpture, not the Church. Rodin also studied both human and equine anatomy, and under the direction of Barye, investigated the anatomy of other animals at the Natural History Museum in Paris. In 1864, soon after the Salon had turned down the powerful and energetic head,* *Man with the Broken Nose*, Rodin encountered the sculptor Albert Ernest Carrier-Belleuse. It turned out to be a turning point for him and in 1871, he followed his friend to Belgium,* leaving behind the difficult years of his youth. MPD

1840 Auguste Rodin is born in Paris on November 12th.

1854–57 Rodin begins his studies at La Petite École, a school specialising in drawing and mathematics, where he discovers sculpture and improves his drawing technique.

1857–59 After leaving La Petite École, Rodin takes the entrance examination for the École des Beaux-Arts, but fails three times. In order to earn a living and to help his family, he works for several decorators and ornamentalists.

1862 Rodin's sister Maria dies in December. He is deeply affected by her death and enters the monastery of the Order of the Holy Sacrament, where he remains until 1863.

1864 Rodin begins to work with Albert Ernest Carrier-Belleuse. He also has his first meeting with Rose Beuret, then aged twenty. His *Man with a Broken Nose* is turned down by the Salon, Paris's most prestigious art exhibition.

1866 His son, Auguste Beuret, is born (out of wedlock) on January 18th.

1870 Together with the Belgian sculptor Antoine-Joseph Van Rasbourg, Rodin visits Brussels. On his return to Paris, he is drafted into the army but is discharged due to poor eyesight.

1871 Rodin travels to Belgium to visit Carrier-Belleuse and works in association with Van Rasbourg. Rose joins him in Brussels at the end of the year.

1874 Rodin takes part in the decoration of the Palais des Académies in Brussels and paints a series of landscapes depicting scenes from the forest of Soignes.

1875 He takes a study visit to Italy. Work also begins on *The Bronze Age*.

1877 Rodin shows *The Bronze Age* in Brussels, then in Paris, where he is accused of having cast the sculpture's features from the mold of a real face. Rodin and Rose return to France, where he works at the Manufacture de Sèvres until December 1882.

1880 The French government acquires *The Bronze Age* and commissions a monumental door for the future Musée des Arts Décoratifs—*The Gates of Hell*.

1882 Rodin sculpts *Adam, Eve*, and *The Thinker*.

1883 Rodin first meets Camille Claudel. He works on a bust of Victor Hugo.

1885 The city council of Calais commissions the *Monument to the Burghers of Calais*.

1886 Rodin sculpts *The Kiss*.

1888 The French government commissions a version of *The Kiss* in marble.

1889 Rodin exhibits alongside Claude Monet at the Galérie Georges Petit. The *Monument to Victor Hugo* is commissioned; it is to be placed in the Pantheon in Paris.

1891 The first proposal for the *Monument to Victor Hugo*, rejected for the Pantheon, is accepted for the Jardin du Luxembourg in Paris. The Société des Gens de Lettres (an authors' association) commissions the *Monument to Balzac*.

1894 In November, Claude Monet invites Rodin to his home in Giverny, where he meets Paul Cézanne for the first time.

1895 Rodin purchases the Villa des Brillants in Meudon, near Paris, which he first rented in 1893. He begins to build a collection of antiques and paintings. In Calais, the *Monument to the Burghers of Calais* is inaugurated.

1898 Rodin has a falling-out out with Camille Claudel. The Société des Gens de Lettres rejects the plaster *Monument to Balzac*.

1899 The *Monument to Puvis de Chavannes* is commissioned. The first exhibition devoted exclusively to Rodin's work is held in Brussels and the Netherlands.

1900 Paris hosts the World's Fair; a pavilion devoted to Rodin's work is set up at the Place de l'Alma.

1902 A large exhibit of Rodin's work is held in Prague.

1904 Rodin's eight-year friendship with the Duchesse de Choiseul begins. A large scale plaster version of *The Thinker* is first shown at the International Society of Painters, Sculptors, and Engravers in London; the bronze version is then shown at the Paris Salon.

1905 Rainer Maria Rilke, whom Rodin first met in 1902, becomes his secretary.

1906 *The Thinker* is placed in front of the Pantheon. Rodin paints watercolors of Cambodian female dancers whom he saw in Marseille.

1907 The first large exhibition devoted to Rodin's drawings is held at the Galérie Bernheim Jeune in Paris.

1908 Rodin sculpts *The Cathedral*. On the advice of Rainer Maria Rilke, he moves to the Hôtel Biron in October.

1909 Inauguration of the *Monument to Victor Hugo* at the Palais-Royal in Paris.

1911 The French government commissions a *Bust of Puvis de Chavannes* for the Pantheon. *The Walking Man* is installed at the Palazzo Farnese in Rome.

1913 At an exhibition at the Faculty of Medicine of the University of Paris, antiques from Rodin's private collection are shown for the first time.

1914 Rodin publishes his *Cathedrals of France*. Fleeing the war, he and Rose go to England, then later stay in Rome.

1915 On another trip to Rome, Rodin sculpts the *Bust of Pope Benedict XV*. The *Monument to the Burghers of Calais* is officially unveiled in London, but with no accompanying ceremony.

1916 Rodin makes three successive donations of his collections to the state. The French government votes to found the Musée Rodin in the Hôtel Biron.

1917 Rodin marries Rose Beuret on January 29th in Meudon. She dies on February 14th. Rodin dies on November 17th. He is buried on November 24th in the garden of the Villa des Brillants in Meudon, next to Rose. *The Thinker* stands over their graves.

1919 The Musée Rodin opens to the public on August 4th.

SELECTED BIBLIOGRAPHY

Bonnet, Anne-Marie. *Auguste Rodin: Erotic Drawings*. London: Thames and Hudson, 1995.

Butler, Ruth. *Rodin in Perspective*. Englewood Cliffs, NJ: Prentice Hall, 1980.

Cladel, Judith. *Rodin*. New York: Harcourt Brace, 1937.

Crone, Rainer. *Rodin: Eros and Creativity*. New York: Prestel, 1992.

De Caso, Jacques, and Patricia Sanders. *Rodin's Thinker: Significant Aspects*. San Francisco: San Francisco Museum of Fine Arts, 1973.

Elsen, Albert. *The Gates of Hell by Auguste Rodin*. Stanford: Stanford University Press, 1985.

Elsen, Albert. *Rodin Rediscovered*. Washington: National Gallery of Art, 1981.

Fergonzi, Flavio. *Rodin and Michelangelo: A Study in Artistic Inspiration*. Philadelphia: Philadelphia Museum of Art, 1997.

Grunfeld, Frederic. *Rodin: A Biography*. New York: Da Capo, 1998.

Judrin, Claudie. *Rodin: Drawings and Watercolors*. New York: Thames and Hudson, 1983.

Lampert, Catherine. *Rodin: Sculpture and Drawings*. London: Arts Council of Great Britain, 1986.

Levkoff, Mary. *Rodin in his Time*. New York: Rizzoli, 2000.

Pinet, Hélène. *Rodin: The Hands of Genius*. New York: Harry N. Abrams, 1992.

Rilke, Rainer Maria. *Auguste Rodin*. New York: Gaskell House Pub Ltd., 1974.

Rodin, Auguste. *Cathedrals of France*. Redding Ridge, CT: Black Swan Books, 1981.

Schmoll, J. A. *Rodin and Camille Claudel*. New York: Prestel, 1999.

I N D E X

With the gracious participation of the Musée Rodin.

Photographic Credits:
All photographs are from the Musée Rodin.
Jean de Calan: 23, 47, 52, 62, 66–67, 68, 69, 70, 82, 86, 89; Béatrice Hatala: 23, 25, 36, 39, 78; Erik and Petra Hermserg: cover, 14 top, 28, 37; Jérôme Manoukian: 31, 38, 54; Adam Rzepka: 8-9, 11, 14 bottom, 17, 22, 32, 33, 35, 41, 47, 53, 57, 76, 80, 93, 98–99, 101, 102–103, 108, 113.

Images by Bruno Jarret (59, 69, 70, 73) and by Adam Rzepka (114) © Adagp, Paris 2002.

Translated and adapted from the French by Susan Pickford
Copy-editing: Kathryn Lancaster
Typesetting: Thierry Renard
Color separation: Pollina S.A., France
Printed and bound by Pollina S.A., France

Originally published as *L'ABCdaire de Rodin* © 2002 Flammarion
English-language edition © 2002 Flammarion Inc.

ISBN: 2-0801-0886-4
FA 0886-02-VIII
Dépôt légal: 09/2002

Printed in France by Pollina s.a.